IMAGES
of America

BURLINGTON

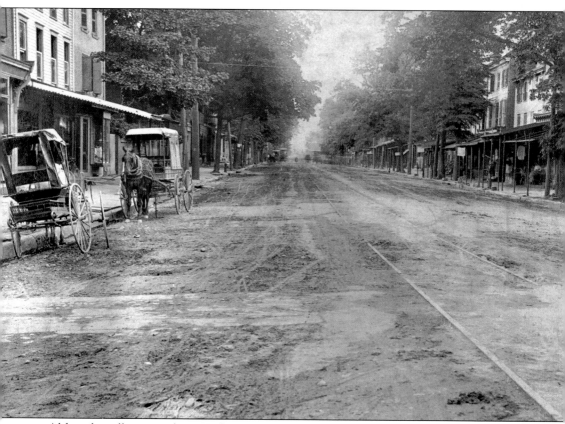

Although trolleys ran along High Street in the early part of the 20th century, horse-drawn carriages were still the preferred mode of transportation for merchants. (Herman Costello.)

IMAGES
of America

BURLINGTON

Martha Esposito Shea and Mike Mathis

ARCADIA
PUBLISHING

Published by Arcadia Publishing
Charleston, South Carolina

Printed in the United States of America

Library of Congress Catalog Card Number: 2001091208

For all general information contact Arcadia Publishing at:
Telephone 843-853-2070
Fax 843-853-0044
E-mail sales@arcadiapublishing.com
For customer service and orders:
Toll-Free 1-888-313-2665

Visit us on the Internet at www.arcadiapublishing.com

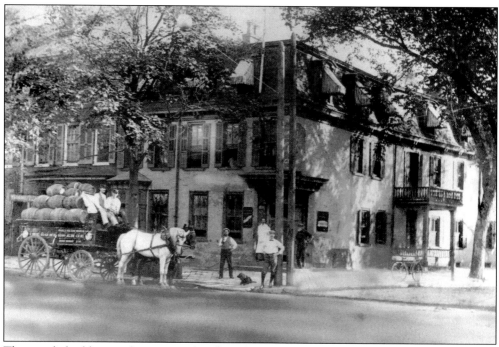

The stately building at the corner of High and East Union Streets has been, over the years, a men's clothing store, a tobacconist, and a florist. (Herman Costello.)

CONTENTS

ACKNOWLEDGMENTS AND DEDICATIONS

The following people were helpful in assisting us with the photographs and the information for this book: Herman Costello, mayor of Burlington; Doug Winterich, director of the Burlington County Historical Society; Joan H. Lanphear; Sarah Bleiler; Robin Snodgrass; and Ron Martin, executive editor of the *Burlington County Times*.

I want to thank my husband, Michael, for his love, patience, support, and scanning expertise. Thanks also to my mother, Harriet Esposito, for her love and support and for being such a good listener.

—Martha Esposito Shea

To Beverly, Melissa, and Michael Jr., thank you for your love and support.

—Mike Mathis

BIBLIOGRAPHY

Bisbee, Henry. *The Burlington Story*.
Burlington County Times.
Common Council of the City of Burlington. *A City's Legacy: An Introduction to the Historic Sites of Burlington*.
DeCou, George. *Burlington: A Provincial Capital*. Harris and Partridge Inc.
Griscom, Lloyd. *The Historic County of Burlington*. The Burlington County Cultural and Heritage Commission.
———. *Burlington County and the American Revolution*. The Burlington County Cultural and Heritage Commission.
McMahon, William. *South Jersey Towns, History and Legend*. Rutgers University Press.
www.bcscream.org

FOREWORD

After the city's founding in 1677, the Council of West Jersey Proprietors was designated by the British crown to oversee the surveying, granting, and purchasing of land within what was then known as West Jersey. Burlington grew to become the birthplace of one of the nation's first volunteer fire companies, as well as noted American author James Fenimore Cooper. It is also home to the Library Company of Burlington, which was founded in 1758 and is the second oldest public library in New Jersey and one of the oldest in the nation. By the start of the 20th century, Burlington was a bustling industrial center with enterprises that included a silk mill, alcohol distillery, and baby shoe manufacturer.

The city of Burlington celebrates its 325th anniversary in 2002. The photographs and postcards in this book open a window on the events that changed the city; they also show how the city effected change on the world over many generations. I marvel at the time when Burlington was a bustling port, rail stop, transportation hub, and center for commerce and manufacturing for all of Burlington County and the world. Burlington continues to build on this rich foundation and its abundant natural advantages, with efforts under way to develop Burlington Island, the largest land mass in the southern part of the Delaware River.

However evocative, the images displayed in this book are but a fraction of Burlington's preserved pictorial heritage. I encourage you to visit the Library Company of Burlington, 23 West Union Street, and the Burlington County Historical Society Museum and Library, 457 High Street, to plunge deeper into the history of our city.

Participating in this endeavor has been very exciting for me. These pages bring back to me the Burlington of the past in vivid detail. The city of Burlington still encompasses the charm of the past, the challenge of the present, and the excitement of the future.

Thank you to all who offered up their visual treasures to enrich and enliven these pages. I also offer my thanks to Burlington's citizens for their confidence in making me so often the steward of the city I love.

—Herman Costello

One

EARLY BEGINNINGS

In 1678, when the British ship *Shield* arrived at Burlington, it was tied to this buttonwood tree on the riverfront. Legend has it that the ship's passengers walked from the ship on the frozen Delaware River to the shore. The English settlers who were the passengers founded the city. (Burlington County Historical Society.)

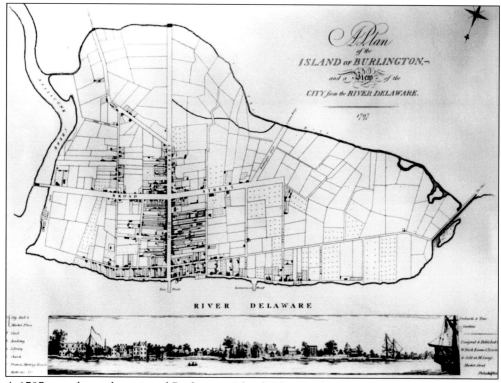

A 1797 map shows the city and Burlington Island. The map lists street names, all of which are still used today. Richard Noble, a surveyor, mapped the town around High Street and laid out the land on each side in lots. As a result, Burlington was one of the first—perhaps even the first—planned city in the land that was to become the United States. (Dennis McDonald.)

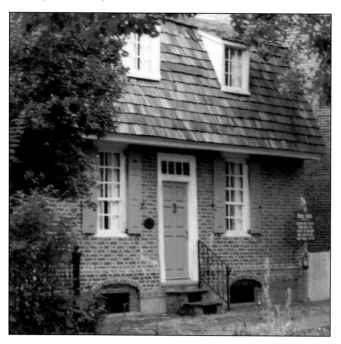

The Revell House, the oldest building in Burlington County, was built near the waterfront by George Hutchinson in 1685. Hutchinson sold the house to Thomas Revell, who had arrived in December 1678 aboard the *Shield* and later became the first clerk of the Burlington court. In the late 1700s, a second floor was added, consisting of a small hall and two rooms. The house was moved to its current location on Wood Street in 1966 when the city made plans to widen Pearl Street. Local historian Henry Bisbee and his wife donated the land for the house. (Burlington County Times.)

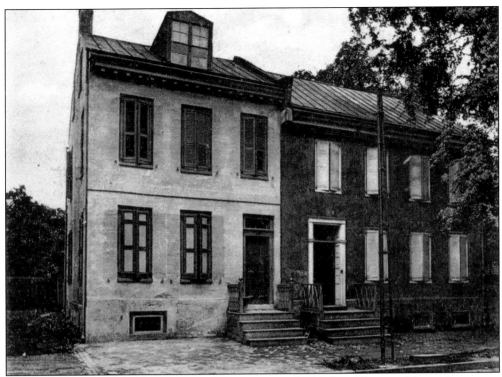

The building on the right of this c. 1906 image was the boyhood home of James Lawrence. Born in 1781, Lawrence had a distinguished naval career, reaching the rank of captain before his death in battle during the War of 1812. Next door, the Cooper House was built in 1780. It is the birthplace of noted American novelist James Fenimore Cooper, who was born in 1789. It became the headquarters of the Burlington County Historical Society in 1923. (Herman Costello.)

The Cooper and Lawrence Houses are shown in 1942. (Herman Costello.)

Built *c.* 1785, the Collins House, located on the corner of Broad and York Streets, was home in the early 1800s to former royal printer and newspaper publisher Isaac Collins. (Burlington County Times.)

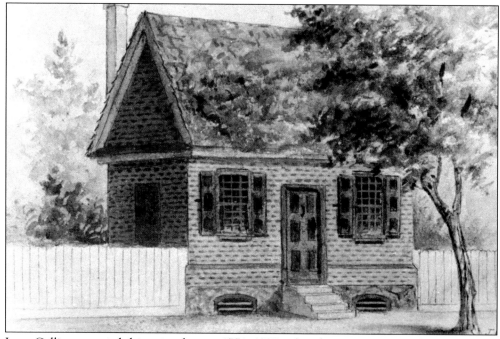

Isaac Collins occupied this print shop in 1771–1778, when he was printer to the king for the Province of New Jersey. Collins also printed continental currency for the American Congress and published the *New Jersey State Gazette* in 1778. The building was torn down in 1881. (Burlington County Historical Society.)

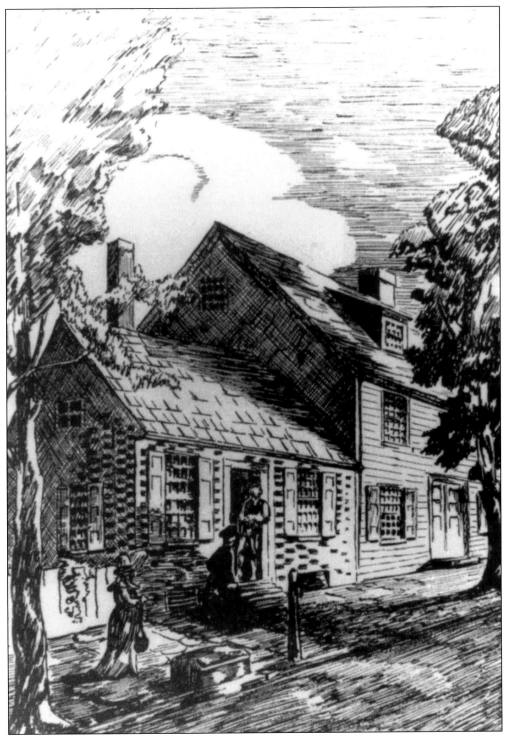

Before Collins used the shop, it was the office of Samuel Jenings, first deputy governor. It was here that Benjamin Franklin printed the first Colonial currency on New Jersey's first copper-plate press. (Burlington County Historical Society.)

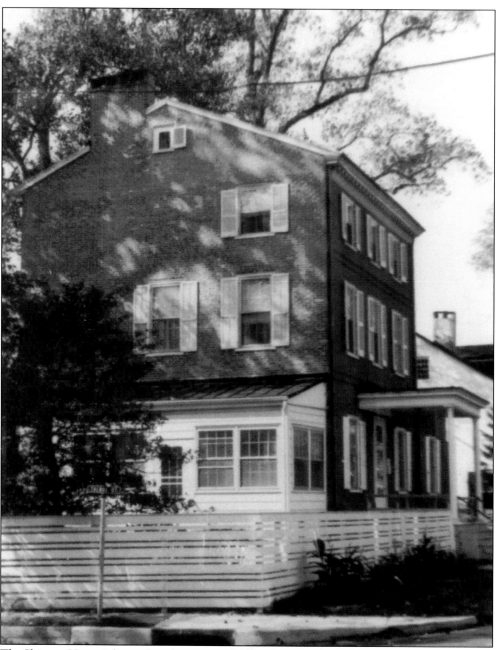

The Shippen House is located on the corner of Talbot Street at the Delaware River. The house was built in 1756 as a summer home for the family of Judge Edward Shippen, a wealthy Philadelphian. In 1778, his 17-year-old daughter Peggy fell in love with and later married Benedict Arnold, an American general who served as a spy for the British during the Revolutionary War. By the end of the war, Arnold, his wife, and their family had moved to London, where they lived the rest of their years in exile. (Burlington County Historical Society.)

The Cromwell House was home to Oliver Cromwell, an African American soldier who served in the Revolutionary War. He was decorated by Gen. George Washington; today, a black history society in the city is named in his honor.

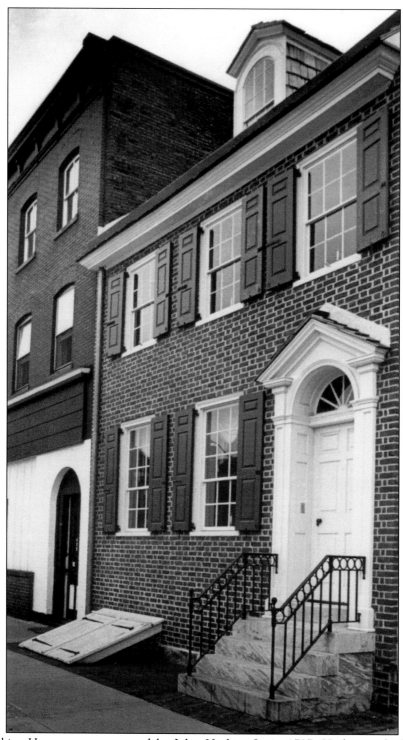

The Hoskins House was constructed by John Hoskins Jr. in 1797. Hoskins, a builder and contractor, was the son of an early member of Burlington government. In 1795, he was one of several people who founded the Endeavor Fire Company. (Dennis McDonald.)

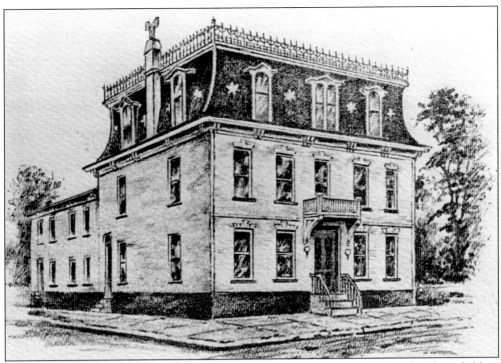

The Birch Mansion on High Street was originally the home of Joseph Bloomfield, a Revolutionary War captain and governor of New Jersey (1801–1812). From 1867 to the early 1900s, it was the home of carriage maker James Birch and his family, having been rebuilt after an 1876 fire that left only the walls standing. Birch built his carriage works behind the mansion and the 1,200-seat Birch Opera House next door. While the opera house is now gone (replaced by a post office), the mansion still stands and is used as an office building. (Burlington County Times.)

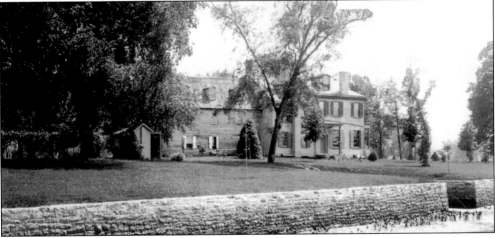

Jegou's Tavern (left), known as the Point House for its location at the mouth of the Assicunk Creek, was located in the home of Dutch settler Peter Jegou in 1668. In 1890, Andrew McNeal, whose McNeal Pipe and Foundry Company later became the U.S. Pipe and Foundry Company, built a mansion next to the tavern site, adjoining the foundry. (Burlington County Historical Society.)

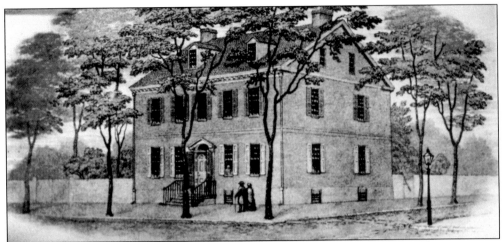

The Grellet House stood on the corner of High and Library Streets and was the home of Etienne de Grellet du Mabillier, better known as Stephen Grellet, a Quaker and world traveler. Grellet died in 1855 and is buried in the Quaker burial ground behind the Burlington Meetinghouse. Two of his Chippendale chairs, donated by his daughter, are in the collection of the Library Company of Burlington. (Burlington County Times.)

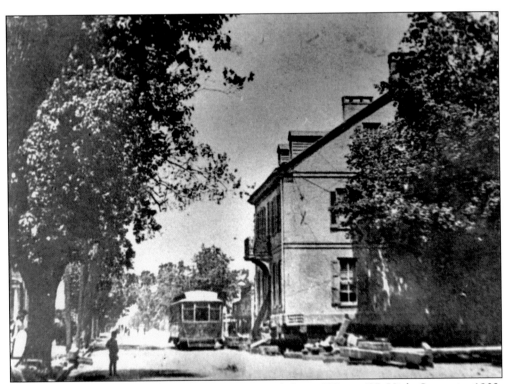

The Grellet House is pictured after it was moved from 413 to 437 High Street in 1902. (Burlington County Times.)

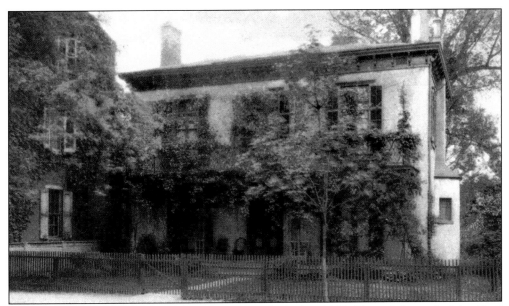

The Grant House on Wood Street is shown as it looked in 1922. Toward the end of the Civil War, Gen. Ulysses S. Grant brought his family to live in this house. Grant and his wife were traveling to this house on April 14, 1865, when they received word that Pres. Abraham Lincoln had been shot. The general accompanied his wife on a special train from Philadelphia to Burlington and then returned to Washington, D.C. (Herman Costello.)

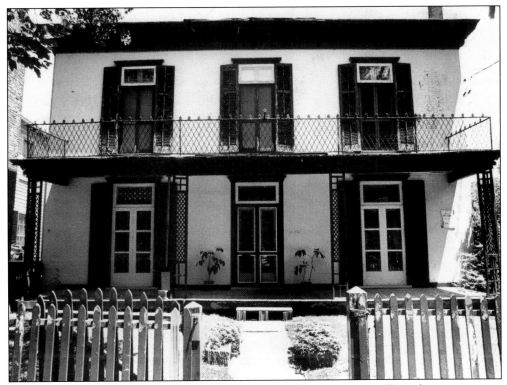

The Grant House is shown as it appeared in 1985. (Burlington County Times.)

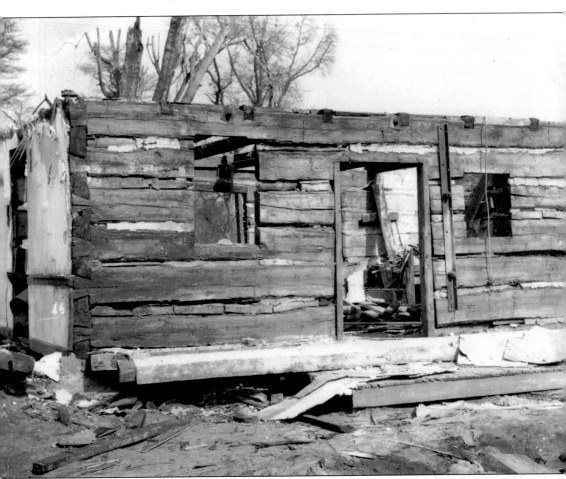

A log house on Burlington Pike (Route 25) near Beverly Road was demolished in March 1949 and rebuilt on a nearby site. The house was probably one of the pioneer homes along the highway, which was authorized *c.* 1747 by the British government. The construction of the house is similar to that used by Swedish settlers in Salem and Cumberland counties. (Burlington County Historical Society.)

Two

PEOPLE

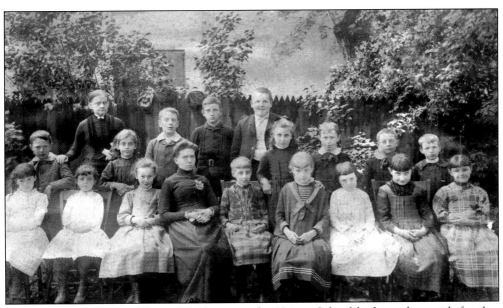

The 1885 class of Mary (Henry S.) Haines at the Haines School had members with familiar Burlington names such as Jessie and Ethel McNeal, Thomas and Daisy Birch, and Anna and Arthur Parrish. (Burlington County Historical Society.)

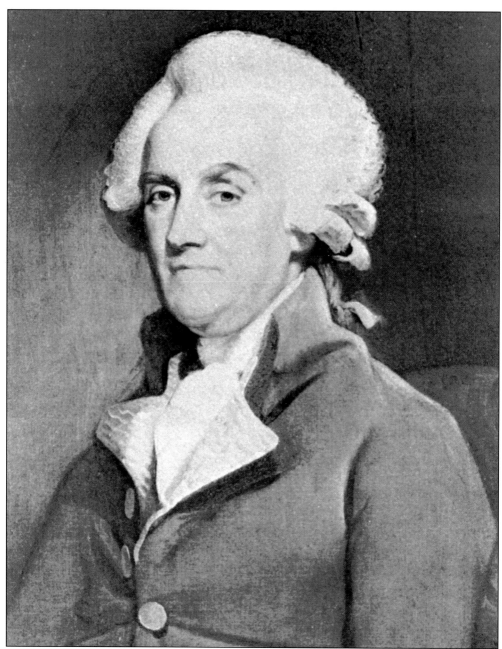

William Franklin, the son of Benjamin Franklin, became royal governor of New Jersey in 1763 at the age of 32 and took up residence at Green Bank, a riverside Burlington mansion. There, he entertained dinner guests such as George Washington. He was instrumental in founding Queens College, now known as Rutgers University. In January 1776, Franklin was placed under house arrest at his second home in northern New Jersey. Five months later, he was seized and brought to Burlington for questioning by the independence-minded Provincial Congress. Refusing to relinquish his authority, he was transported to Connecticut and held as a prisoner of war for two and a half years. He then spent a few years as the leader of a Tory association in New York before returning to England in 1782. (Burlington County Times.)

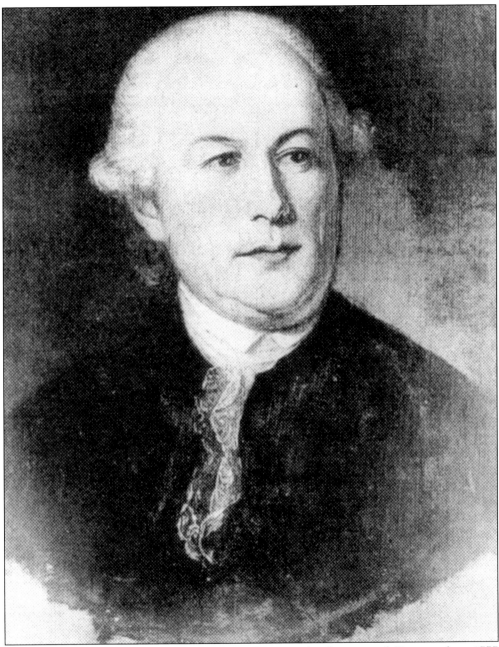

Elias Boudinot served as a delegate from New Jersey to the Continental Congress from 1777 to 1778, and again from 1781 to 1784. In 1783, as president of the Continental Congress, he signed the Treaty of Paris. After the Constitution was ratified, he served as U.S. representative from 1789 to 1795, then was appointed director of the U.S. Mint. He moved to his house on West Broad Street in 1804 and served as a trustee of what is now Princeton University, where he founded the natural history department in 1805. He died in Burlington in 1821 and is buried in St. Mary's churchyard with his wife, Hannah Stockton Boudinot. (Burlington County Times.)

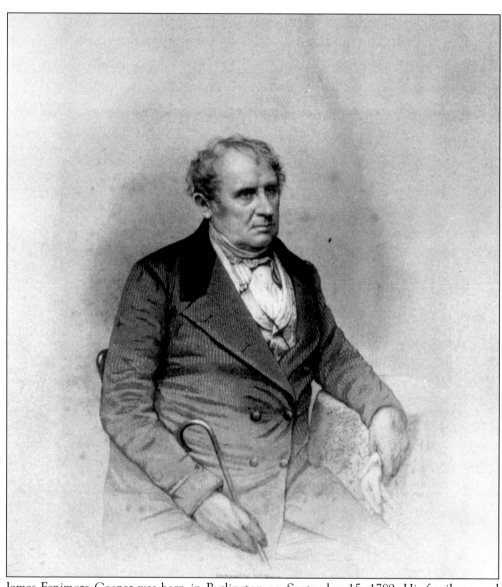

James Fenimore Cooper was born in Burlington on September 15, 1789. His family moved to upstate New York when he was only a year old. His experiences growing up in the region influenced Cooper to author several books about the American wilderness, including *The Deerslayer* and *Last of the Mohicans*. (Burlington County Times.)

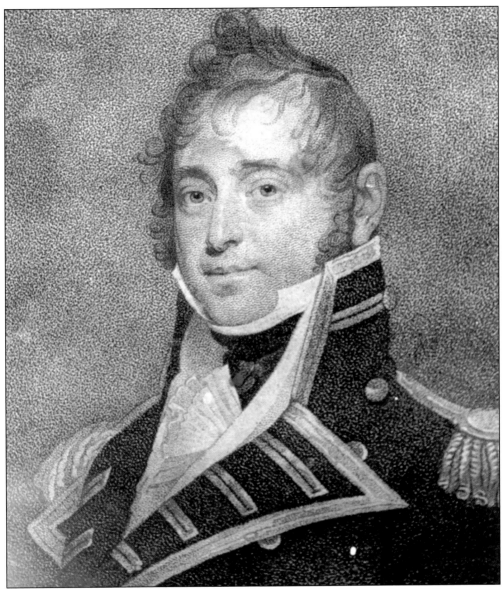

James Lawrence was born in Burlington on October 1, 1781. He joined the U.S. Navy as a midshipman in 1798 and gained experience in action against the Barbary pirates. During the War of 1812, Lawrence commanded an untrained crew on the 49-gun frigate USS *Chesapeake* off Boston. During a battle, Lawrence shouted, "Tell the men to fire faster and not to give up the ship; fight her till she sinks!" Every officer fought until he was either killed or wounded, but the battle was lost in under an hour. The *Chesapeake* was captured, and Lawrence died four days later, leaving his wife and a daughter.

In honor of Captain Lawrence, a group of women stitched the words "Don't Give Up The Ship" into a flag. The flag was presented to Oliver Hazard Perry (commander of the USS *Lawrence*, named for Captain Lawrence) in the summer of 1813. Lawrence's words became the motto of the U.S. Navy, which has named numerous ships in his honor. Perry's flag now hangs in a place of honor at the U.S. Naval Academy in Annapolis, Maryland. (Burlington County Historical Society.)

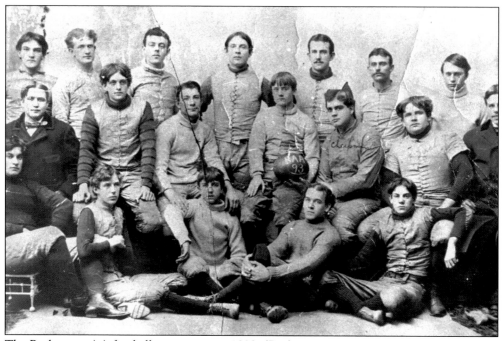

The Burlington AA football team poses in 1893. (Burlington County Historical Society.)

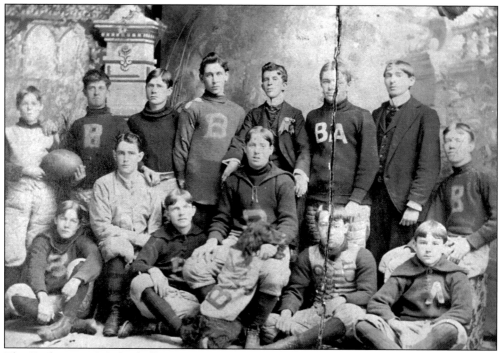

The Burlington AA football team won the county championship in 1895. Note the team mascot is wearing his own jersey. (Herman Costello.)

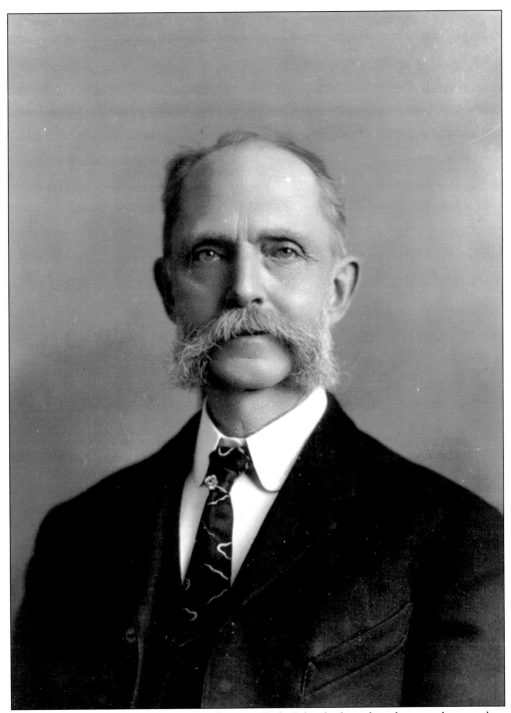

Wilbur Watts was the principal of Burlington High School when this photograph was taken in 1910. The high school was later named after Watts and, in 1967, the building became the Wilbur Watts Middle School. Watts was an instructor in the city schools for 50 years, serving as principal of the boys' grammar school from 1866 to 1887 and supervising principal of the schools from 1887 to 1916. He died in 1921. (Burlington County Historical Society.)

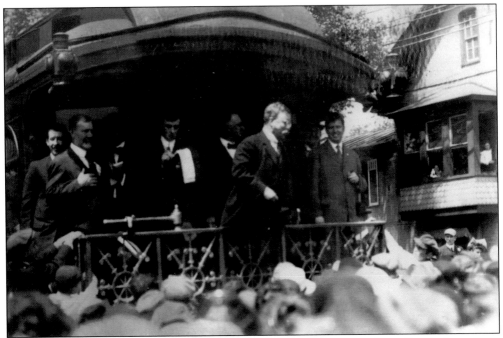

Pres. Theodore Roosevelt waves to a crowd of people from the rear of a trolley during a 1912 campaign stop in Burlington. (Herman Costello.)

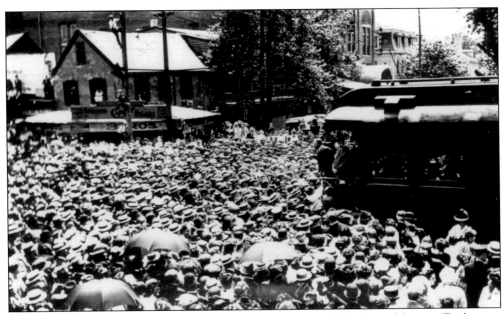

Thousands turned out to see Roosevelt, the 26th president of the United States. (Burlington County Historical Society.)

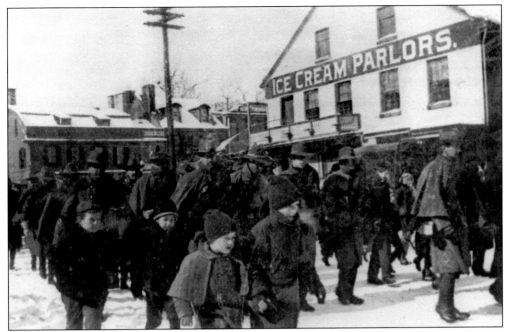

Veterans of the Spanish-American War return home to Burlington. (Herman Costello.)

World War I veterans parade past appreciative Burlington residents. (Herman Costello.)

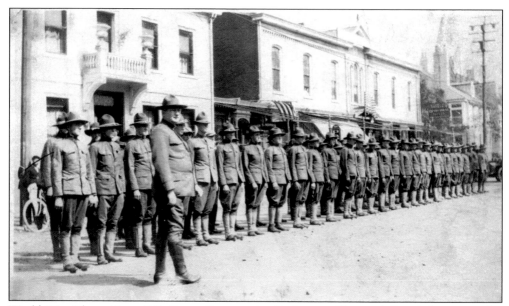

World War I hero Capt. E.B. Stone lines up the Burlington National Guard, known as the Burlington Boys, for inspection in 1918. (Herman Costello.)

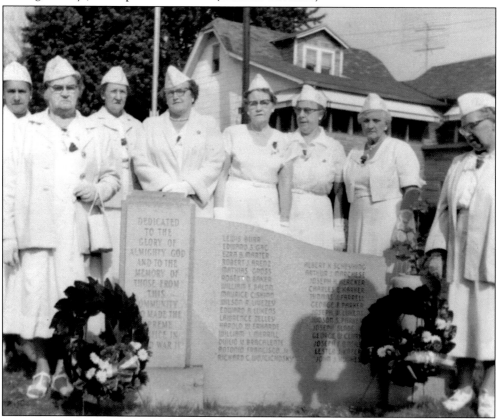

Gold Star Mothers, whose sons were killed in World War II, gather in 1956 at the memorial that bears the names of their sons. (Herman Costello.)

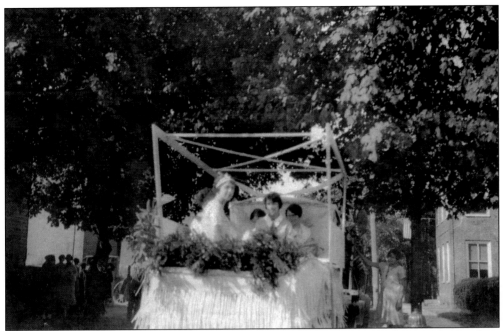

Riding the YMCA float during the city's 250th anniversary parade on July 4, 1927, are, from left to right, Ottilie Powell, Isabelle Abdill, and Flora Cassady. (Herman Costello.)

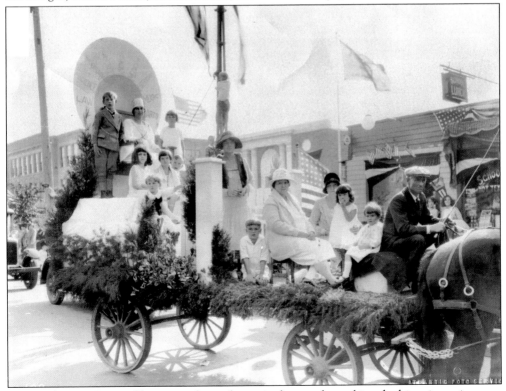

Miss Burlington City and her court also took part in the parade marking the historic anniversary. (Herman Costello.)

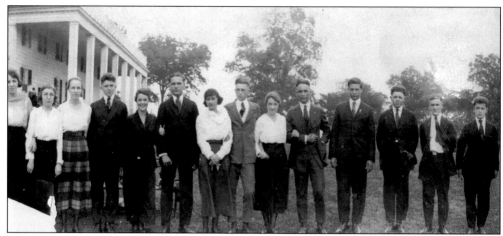

J. Cresswell Stuart is pictured fourth from left on his Burlington High School class trip to Washington, D.C., in 1920. One of Willingboro's elementary schools was named after Stuart. He was a member of one of the last farming families of Willingboro, which was developed into a modern suburb by William Levitt. (Burlington County Historical Society.)

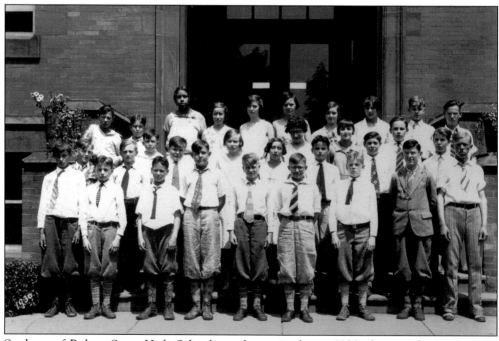

Students of Robert Stacy High School are shown in this c. 1930 photograph. Stacy was a 17th-century Quaker who bequeathed Burlington Island to the city school district. (Burlington County Historical Society.)

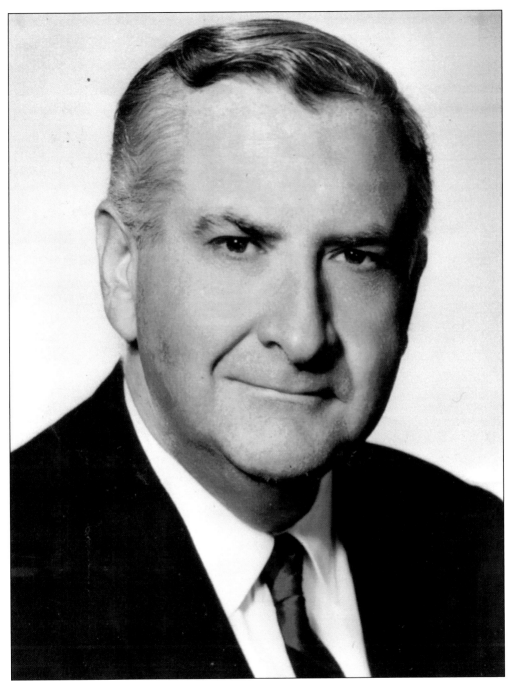

Sidney W. Bookbinder was a well-known and well-respected Burlington City attorney. He practiced law for nearly 50 years and played a major role in the city's historical restoration by spearheading a re-creation of the Grellet House, which is now used as an office complex. The community of Willingboro named a school in honor of the longtime attorney of the Willingboro school, planning, and zoning boards and township council. The uncle of state superior court judge Ronald Bookbinder, Sidney Bookbinder died in August 1984 at the age of 71. (Burlington County Times.)

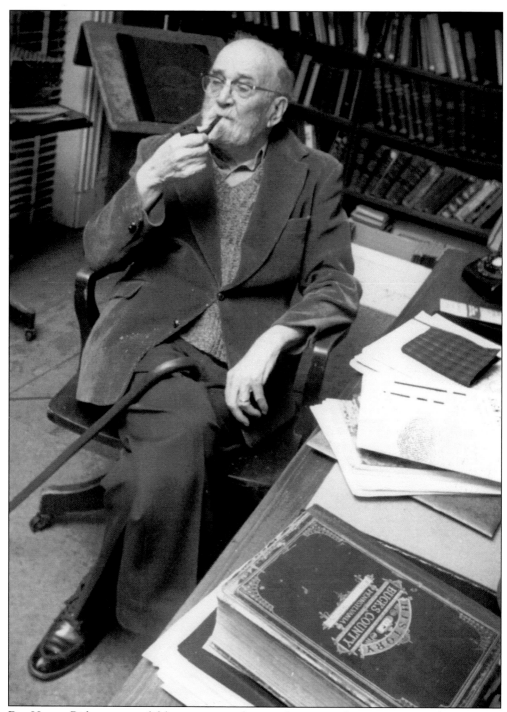

Dr. Henry Bisbee was a lifelong city resident and renowned expert in city history. An optometrist, Bisbee authored a dozen books and scores of articles on Burlington County history. He served a 10-year tenure as Burlington County historian. Bisbee died in 1994 at the age of 87. (Larry Savich.)

Alexander Denbo was another well-known and respected attorney in Burlington County. Denbo went straight from Burlington High School to the Dickinson School of Law in Carlisle, Pennsylvania, and maintained a law office in Burlington for more than 60 years. Denbo's more than 50 years of service as a school board attorney of the Pemberton Township School District was marked in 1977 when the former Oakview Elementary School was named in his honor. (Burlington County Times.)

Herman Costello has been the mayor of Burlington for most of the last three decades. A lifelong city resident, Costello is a former state assemblyman whose political career began when he was elected to the city council in 1958. Costello is perhaps Burlington's most vocal cheerleader, a staunch promoter of the city's historic attributes, and a supporter of urban renewal, which has helped position the city's reemergence as a tourist spot and residential community. (Dennis McDonald.)

Three

COMMUNITY
FOUNDATIONS

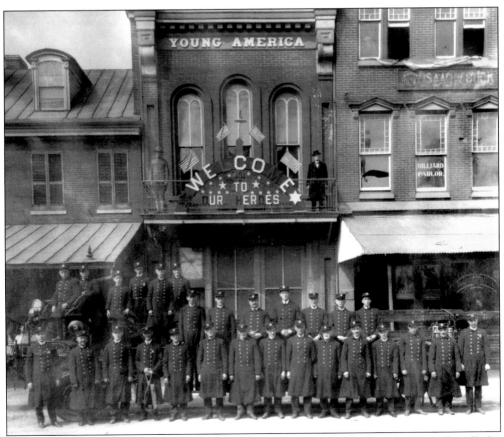

Several of Young America's early firefighters pose in front of the firehouse. (Herman Costello.)

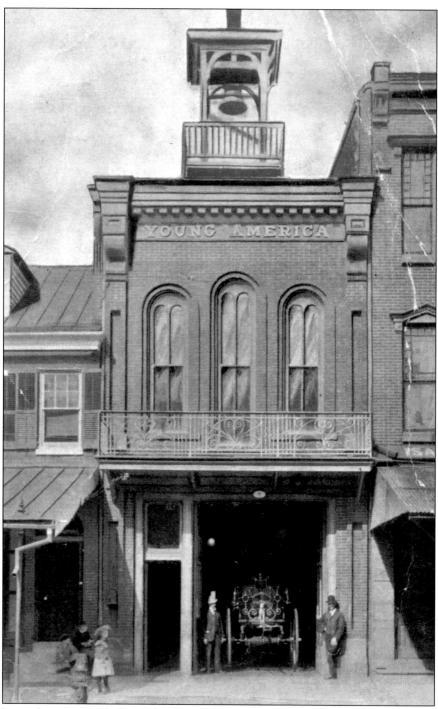

The Young America Hook & Ladder Company was organized in 1857. Originally housed on East Pearl Street, the company merged in 1869 with the Franklin Fire Engine Company No. 3, which had been organized in 1852. The new company took the name Young America Fire Company No. 3 and, in 1870, built and occupied its present firehouse at 21 East Broad Street. (Herman Costello.)

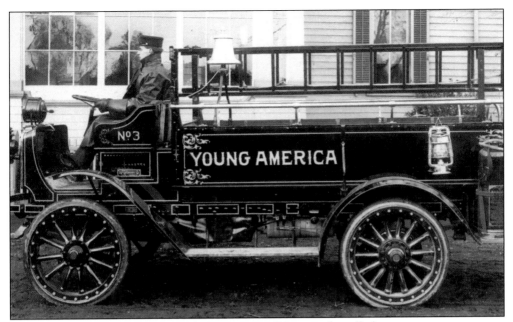

This is one of Young America's early fire engines. (Herman Costello.)

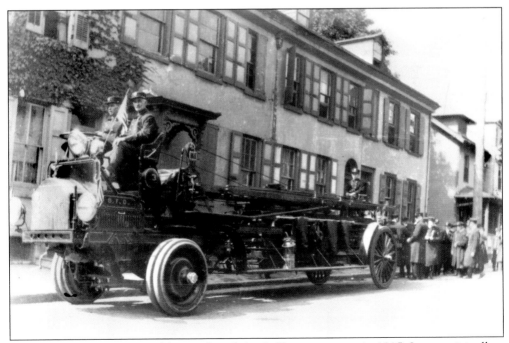

Young America Hook & Ladder purchased this LaFrance steamer in 1915. It was originally a horse-drawn vehicle. (Herman Costello.)

The Hope Hose Company traces its origins to the mid-1800s through a series of consolidations that took place among fire companies in Burlington. Hope Hose occupied a firehouse on High Street for more than 100 years until 1969, when it moved across High Street to its current location. (Herman Costello.)

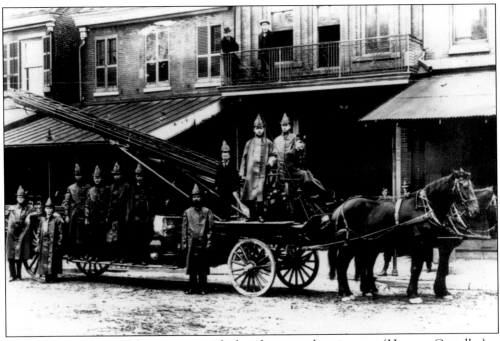

Some of the city's proud firemen pose with their horses and equipment. (Herman Costello.)

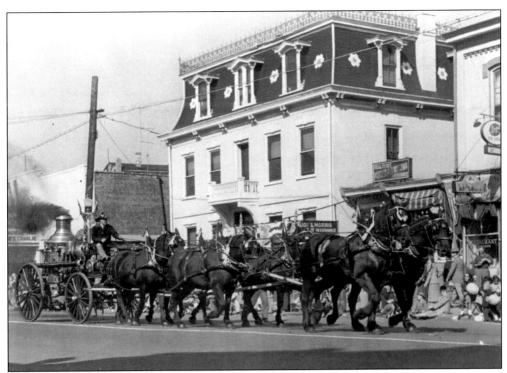

A fire parade goes past the Birch Mansion on High Street. (Herman Costello.)

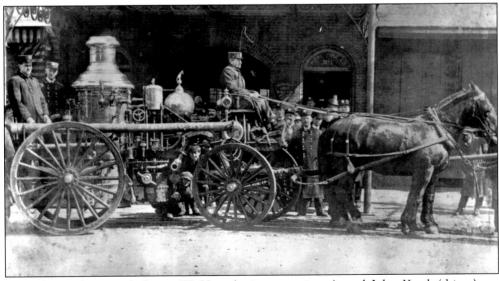

Nat Johnson (engineer), James W. Horn (assistant engineer), and John Kerch (driver) are shown with the Hope No. 1 steam engine in a photograph originally published in the *New York Sunday World*. (Burlington County Historical Society.)

Bucket brigades were the city's first method of firefighting until 1742, when the city received permission to form fire companies. The Endeavor Fire Company No. 1, founded in 1795, is the oldest of the city's fire companies. (Herman Costello.)

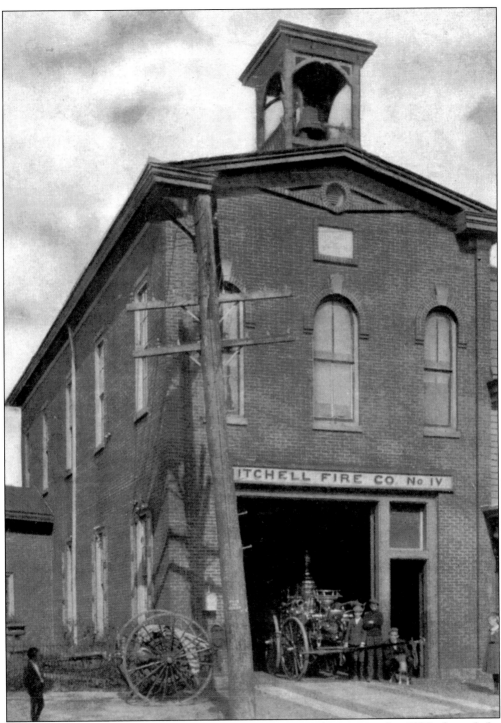

The shoemakers whose businesses were prominent in Burlington in the 1870s formed the Mitchell Fire Company. Their original firehouse still stands at the corner of Lawrence and Federal Streets, but the company is now located in more modern quarters at Mitchell and Federal Streets. (Herman Costello.)

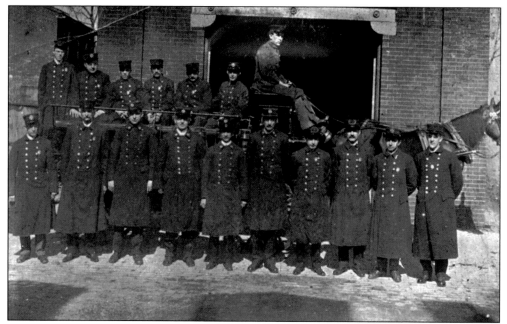

The members of the city's Salvage Corps pose for a photograph. (Herman Costello.)

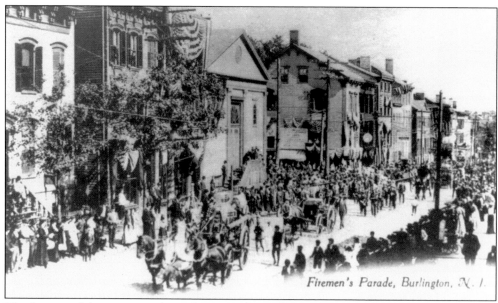

Firemen's Parade, Burlington, N. J.

The firemen of the city were always happy to show off their finery and equipment. (Burlington County Historical Society.)

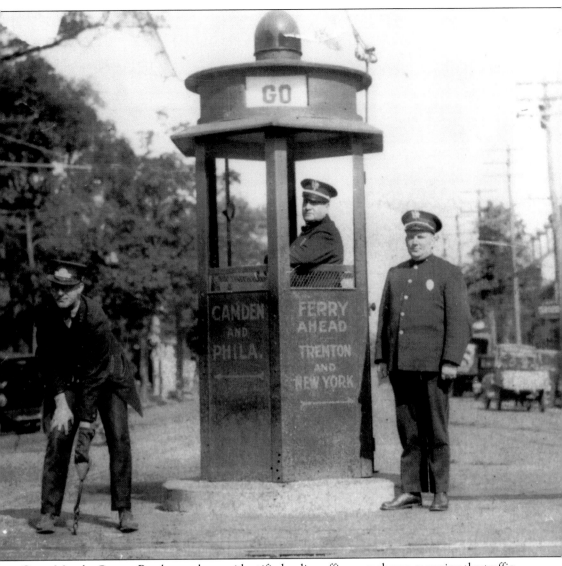

Oscar Morely, George Bowley, and an unidentified police officer are shown manning the traffic booth at the intersection of High and Broad Streets. (Herman Costello.)

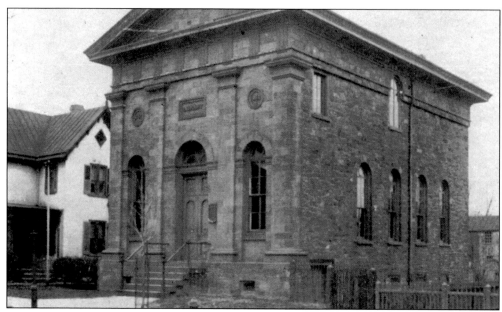

The Library Company of Burlington is the second oldest public library in New Jersey and the seventh oldest in the nation. It has operated continuously since 1758, when it was chartered by King George II of England. The library was the first to print a catalogue, also in 1758. Most of its original 700 volumes were gifts from prominent residents. (Herman Costello.)

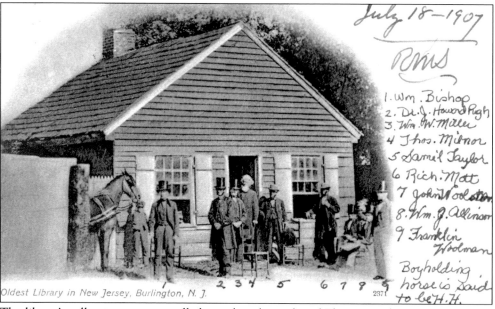

Oldest Library in New Jersey, Burlington, N. J.

The library's collection was originally housed in the parlor of Thomas Rodman's house at 446 High Street but was moved in 1767 to Robert Smith's house at 218 High Street. In 1789, Capt. Joseph Bloomfield donated a piece of land on Office Street, near his mansion. A small building was constructed to house the collection and became the first library building in New Jersey. This provided a place for the library's first permanent home, and the small side street adjacent to Bloomfield's house was renamed Library Street, a name that remains to this day. (Herman Costello.)

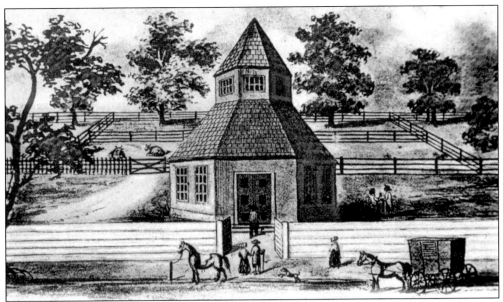

The first Burlington Meetinghouse—a hexagonal wooden structure—was built in 1683 and served for 100 years. It was seized during the Revolutionary War and used as a barracks. (Herman Costello.)

The present Burlington Meetinghouse on High Street was constructed in the mid-1780s by the Society of Friends to replace the original smaller structure. In 1994 and 1995, major renovations and additions converted the meetinghouse into a conference center. Interred in the burial ground are Joseph Taylor (founder of Bryn Mawr College), printer Isaac Collins, and missionary Stephen Grellet. (Herman Costello.)

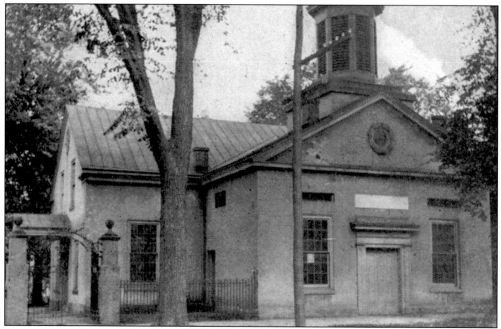

Located at the corner of West Broad and Wood Streets, Old St. Mary's was constructed in 1703 and is the oldest Episcopal church in New Jersey. Its silver communion service was a gift from Queen Anne before her death in 1713. Its first rector, John Talbot, had been a ship's chaplain and served as pastor from 1705 to 1725. The church was expanded over the years and, in 1799, a guild house was constructed at the corner of West Broad and Talbot Streets. (Herman Costello.)

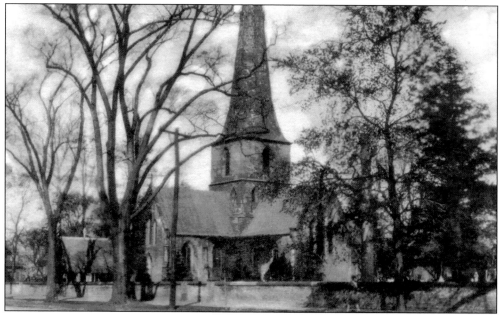

By the mid-1800s, the congregation needed a new home, and the new St. Mary's Church was constructed across the churchyard from the old church between 1846 and 1854. Among those buried in the churchyard are former governor Joseph Bloomfield and Elias Boudinot. (Herman Costello.)

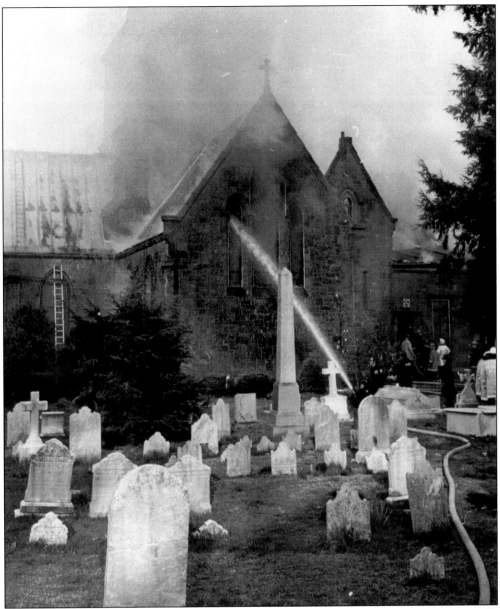

St. Mary's Church was gutted by a fire in April 1976, leaving nothing but the stone walls standing. Services were held in Old St. Mary's while the interior of the new church was rebuilt. (Burlington County Times.)

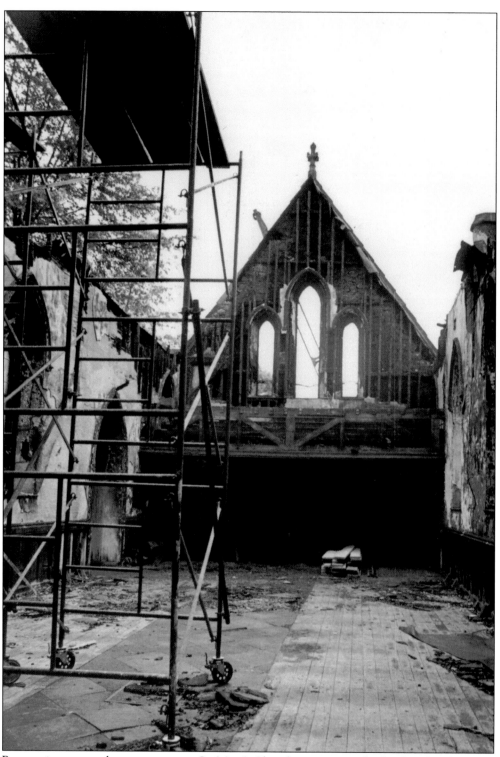

Renovations get under way to restore St. Mary's Church to its original splendor after the April 1976 fire. (Burlington County Times.)

St. Paul's Roman Catholic Church is home to one of the oldest Catholic congregations in Burlington County. (Herman Costello.)

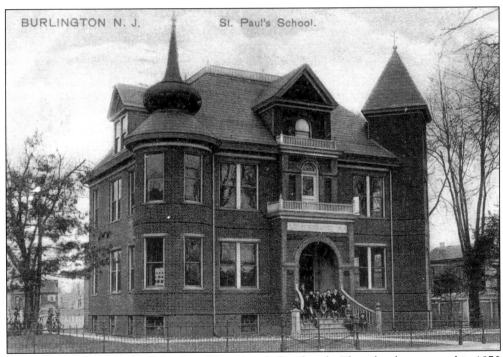

St. Paul's Roman Catholic School is affiliated with the church. The school was started in 1870 in the basement of what is now the Knights of Columbus Hall on Broad Street. The current school building was built in 1960. The parish dates from 1864. (Herman Costello.)

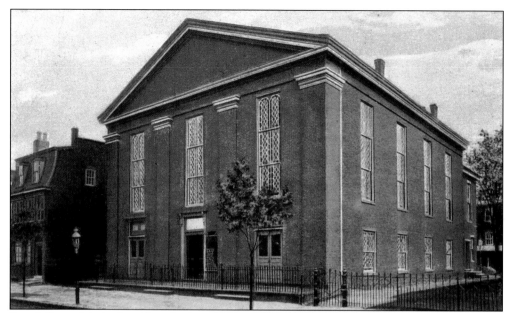

Broad Street Methodist Church, founded in 1788, was built Broad and Lawrence Streets in 1820. The church was founded by Capt. Thomas Webb, a British army officer stationed in Burlington City. The site had previously been the location of the Burlington County jail. Oliver Cromwell, an African American veteran of the Revolutionary War, is among those buried in the church cemetery. (Herman Costello.)

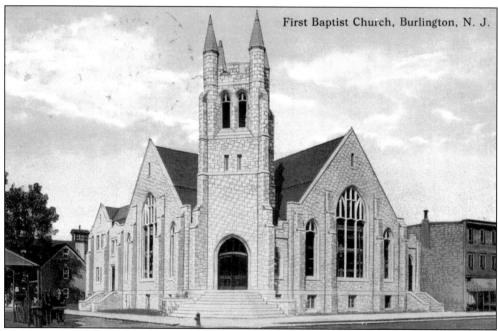

The First Baptist Church on Broad Street was established in 1801. (Herman Costello.)

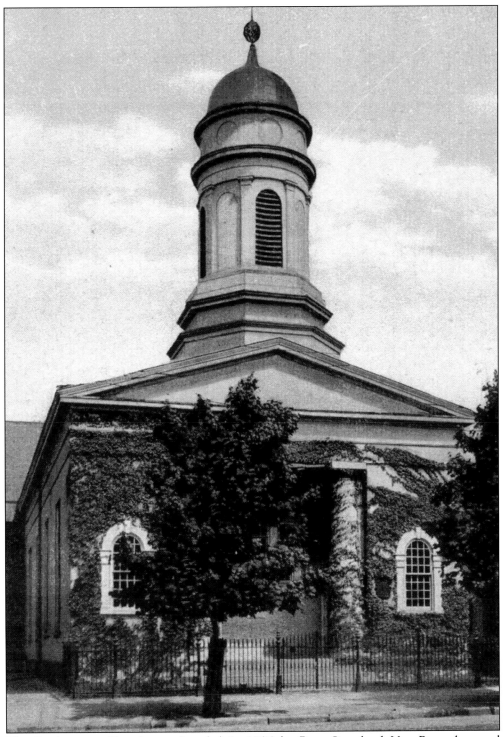

The Presbyterian Church was founded in 1836 by Rev. Courtland Van Rensselaer and Dr. William Chester. Today the building is gone (it was located at High and Pearl Streets), but the congregation meets in neighboring Burlington Township. (Herman Costello.)

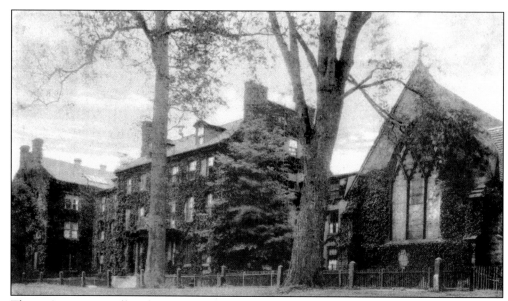

This is St. Mary's Hall and the Chapel of the Holy Innocents, located along the banks of the Delaware River. St. Mary's Hall–Doane Academy was founded by George Washington Doane, the bishop of the New Jersey Episcopal Diocese and rector of St. Mary's Church. Financial difficulties nearly forced the school's closure in 2000, but the institution continued to operate in 2001 thanks to a government loan. (Herman Costello.)

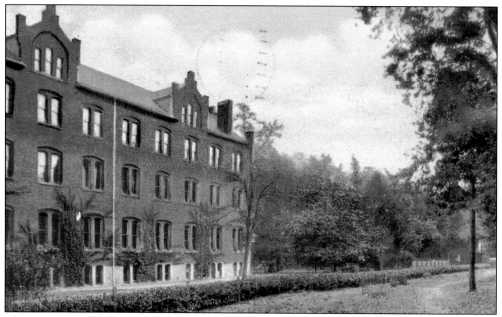

These are some of the students' rooms at St. Mary's Hall–Doane Academy when the private school had accommodations for students who lived on campus. (Herman Costello.)

This was the home of George Washington Doane, who served as bishop of the New Jersey Episcopal Diocese and as rector of St. Mary's Church. In 1837, Doane purchased the old Gummere Academy on the riverfront in 1837 and founded St. Mary's Hall for Girls, a private school. The house, called Riverside, was built c. 1839 and later contained classrooms for the school. The house was demolished in 1961. (Herman Costello.)

St. Barnabas Episcopal Church was founded in 1856 by George Washington Doane, the pastor of St. Mary's and the founder of St. Mary's Hall, because of the reluctance of parishioners from St. Mary's to admit the poor. The parishioners first met in an old schoolhouse at Broad and St. Mary Streets that was converted into a chapel. (Herman Costello.)

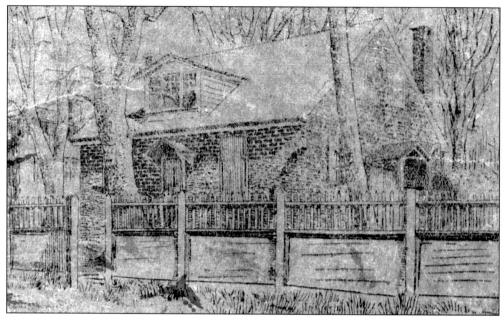

The city's Quaker school, located at York and Penn Streets, is more than 200 years old, making it one of Burlington County's oldest school buildings. This newspaper drawing first appeared in 1910. (Burlington County Historical Society.)

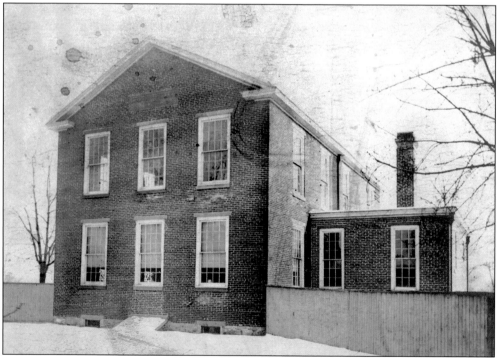

The Stephen Grellet School, located on Bordentown Road at Jones Street, closed in 1943. It had two classrooms and an attic. (Burlington County Historical Society.)

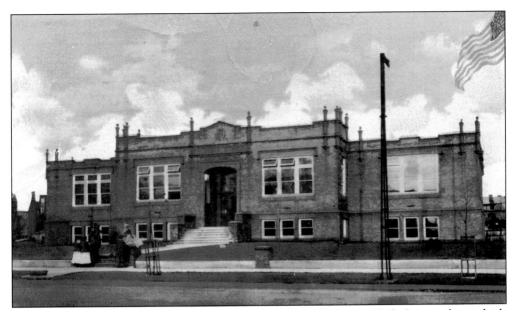

The Robert Stacy School operated for 72 years before closing in 1983. It served as a high school, junior high school, and elementary school. The school opened as a four-year high school in 1911 with 159 students from as far away as Florence and Palmyra. By 1922, the school population had increased nearly fourfold, and the district moved high school classes across High Street to the new Wilbur Watts High School. The Stacy School then became a junior high school. Stacy was a 17th-century Quaker who bequeathed Burlington Island to the school district. (Herman Costello.)

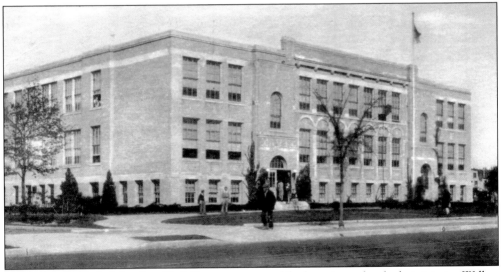

Wilbur Watts High School on High Street was named for longtime school administrator Wilbur Watts, who worked in the city schools from the late 19th century through the early 20th century. The building, which was the original Burlington High School, was named the Wilbur Watts Middle School in 1967 in honor of the educator who had died that year. The building is slated for demolition by 2002. (Herman Costello.)

The William R. Allen School, which was built in 1900, was Burlington City's third school built for the education of African American children. It was named for Allen, a mayor of the city during the Civil War and well-known local businessman. The school closed in the 1960s. (Dennis McDonald.)

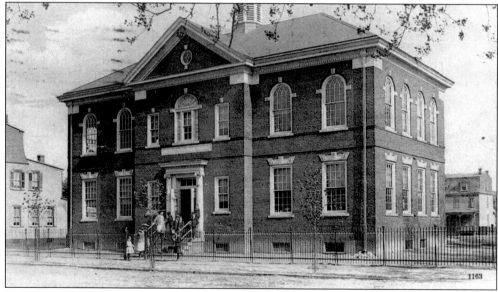

The Elias Boudinot School was named for Elias Boudinot, a delegate to the Continental Congress from New Jersey, a U.S. representative from New Jersey from 1789 to 1795, and director of the U.S. Mint from October 1795 to July 1805. Born in Philadelphia in May 1740, Boudinot died in Burlington in October 1821. He is buried in St. Mary's Cemetery. (Herman Costello.)

In 1899, the Burlington Board of Education renamed its schools to honor the city's famous residents. The St. Mary's Street School became the Capt. James Lawrence School. (Herman Costello.)

The James Fenimore Cooper School was named for author James Fenimore Cooper, who was born in Burlington but spent most of his youth in upstate New York. (Herman Costello.)

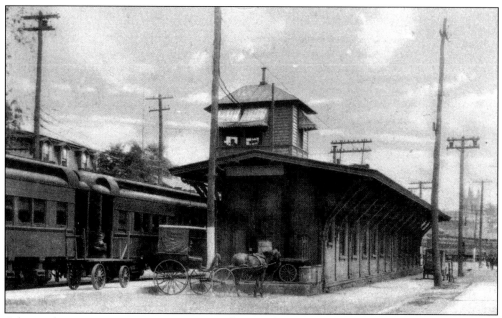

A horse-drawn carriage awaits as a train pulls into the station. (Herman Costello.)

As seen on a 1909 postcard, the station of the Pennsylvania Railroad was on Broad Street in close proximity to the Belden House, a favorite way station for travelers. (Herman Costello.)

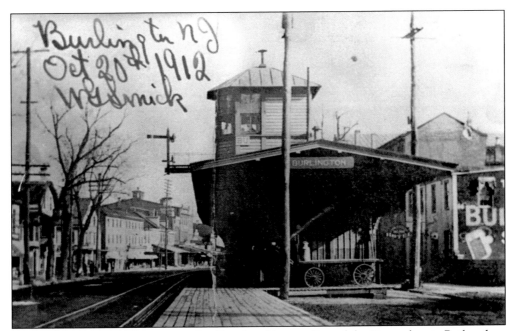

This is the Burlington Station on the Camden–Trenton line of the Pennsylvania Railroad on West Broad Street as it appeared in October 1912. The railroad played an important role in the emergence of Burlington as a center of commerce in the 19th and 20th centuries. (Herman Costello.)

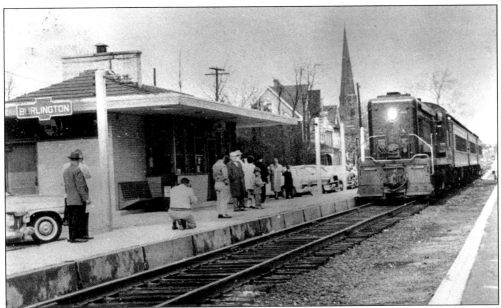

The famous "Nellie Bly" of the Pennsylvania Railroad took its last trip on April 29, 1961. (Herman Costello.)

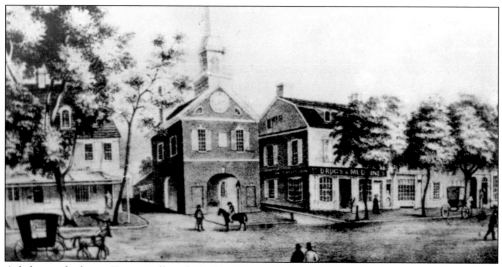

A lithograph shows Town Hall and Market House, built in 1797, with Anderson's Drug Store on the right. (Herman Costello.)

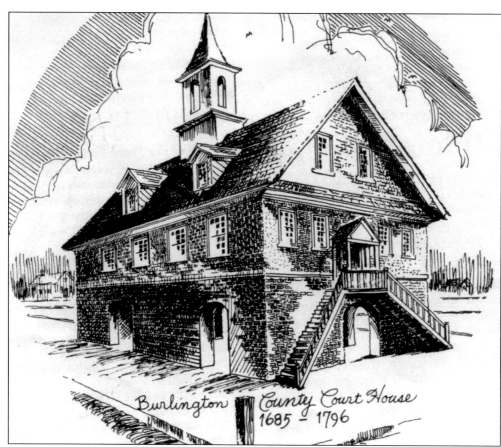

Burlington County Court House 1685 – 1796

The Old Court House, built in 1683 by Francis Collins, was sold to the city in 1797 for 170 pounds after the county courthouse was built in Mount Holly. (Burlington County Times.)

The Daughters of the American Revolution once used the Revell House as its headquarters. (Herman Costello.)

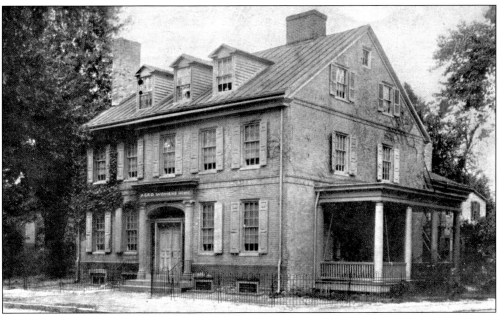

The Home for Aged Women has been a landmark in the city for more than 100 years. In May 1896, a group of women met to form an organization to house "elderly women of good moral character without many worldly goods." The home first opened its doors at East Broad and York Streets on October 8, 1896. Two years later, it moved to larger quarters where St. Paul's Roman Catholic Church now stands. In March 1906, the home was relocated to this three-story house at East Union and York Streets. (Herman Costello.)

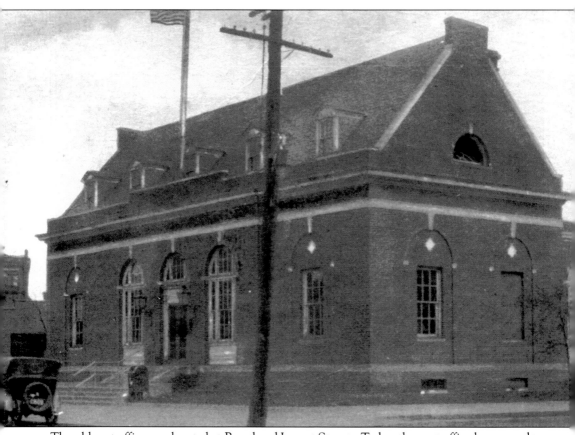

The old post office was located at Broad and Locust Streets. Today, the post office has moved to modern quarters on High Street and a bank occupies the old site. (Herman Costello.)

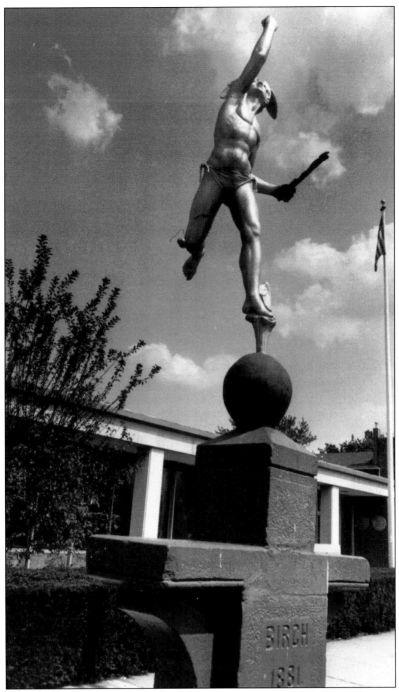

The statue of Mercury was erected by James H. Birch (a wealthy city resident who manufactured rickshaws and carriages) for his opera house, which stood on the site of the current post office on High Street. The opera house, erected in 1877, was demolished in the 1950s. Among the famous entertainers who appeared there were Col. William "Buffalo Bill" Cody, the Cohans, Pat Rooney, and Tony Pastor. On the statue's base are engraved the name Birch and 1881, the year it was originally placed at the opera house. (Nancy Rokos.)

The National Guard Armory, located on High Street, is still in use today. (Herman Costello.)

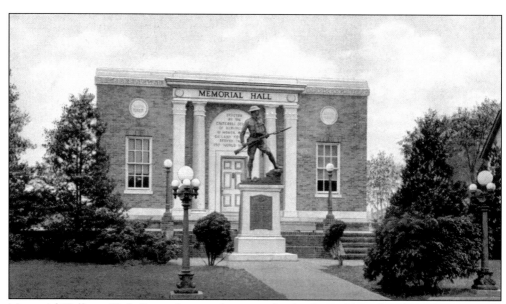

Memorial Hall, on High Street, honors the men who fought and lost their lives during World War I. (Herman Costello.)

Four

ON THE WATER

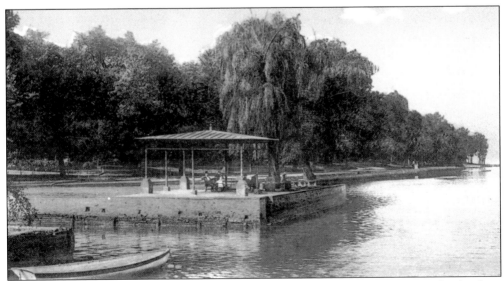

A pavilion provided shade and a quiet vantage point for those relaxing in Green Bank, along the Delaware River. (Herman Costello.)

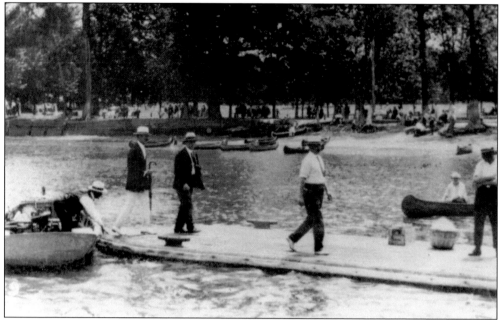

The first Europeans to settle on Burlington Island (1624) were the Walloons—French-speaking Hollanders from what is now Belgium. Nearly 300 years later, the island (in the Delaware River between East Burlington and Bristol, Pennsylvania) was home to a picnic grove and amusement park. Visitors arrived by ferry, paddle wheelers, or pleasure boats to spend the day. (Herman Costello.)

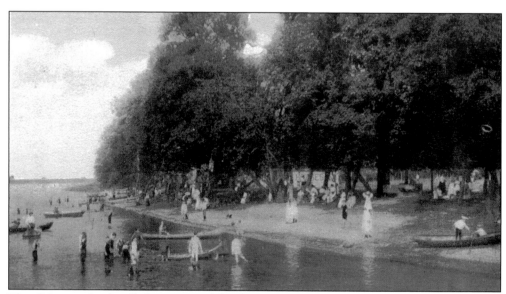

The 400-acre island, called Matineconk by the Lenni Lenape Indians, was laid out as a picnic ground and beach before the beginning of the 20th century. (Herman Costello.)

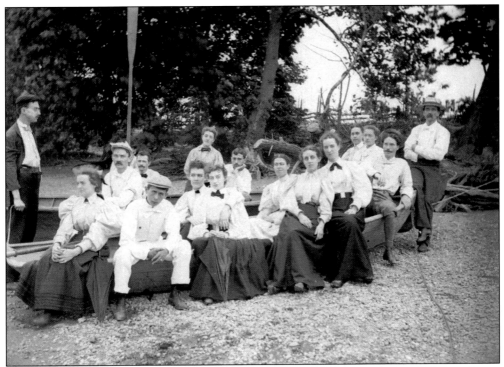

Visitors pose for a portrait on the island in 1890. (Burlington County Historical Society.)

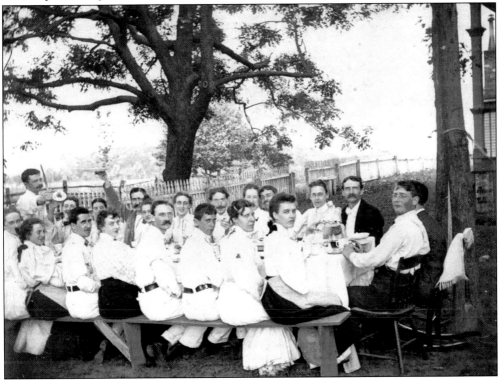

A Fourth of July picnic in the grove is shown c. 1900. (Burlington County Historical Society.)

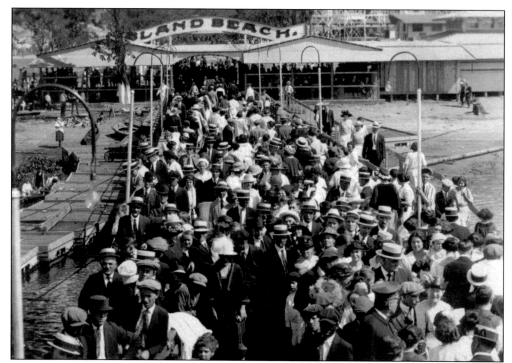

In 1917, a New York company turned the picnic grove and beach into Island Beach, a 100-acre amusement park. Tourists flocked to the island to spend a day on rides, such as a Ferris wheel and roller coaster. (Herman Costello.)

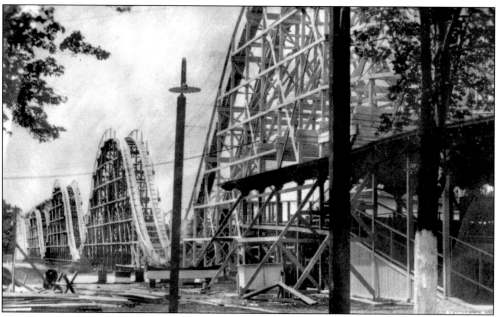

The Grey Hound roller coaster dominated the amusement park. It was destroyed in a 1928 fire that decimated most of the park; whatever was left standing became victim of another fire in 1935. (Herman Costello.)

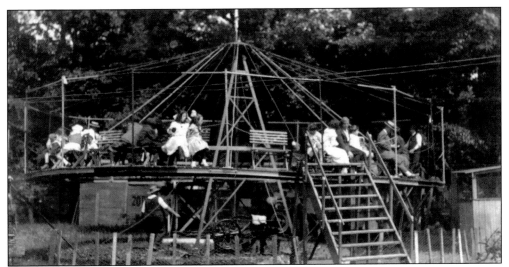

The Ocean Wave ride attracted families, youngsters, and courting couples. (Herman Costello.)

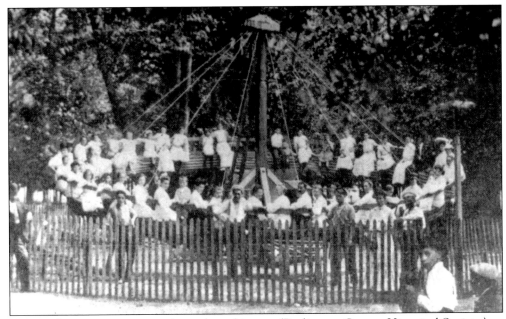

Among the attractions were rides such as this one. (Burlington County Historical Society.)

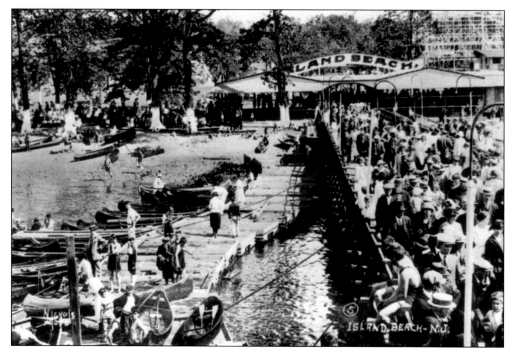

Canoes were a form of recreation for those who preferred their thrills on the water. (Burlington County Historical Society.)

On hot summer days, people from across the area could be found on the island. (Herman Costello.)

The island's concession area was a treat for many, photographed in 1916. (Burlington County Historical Society.)

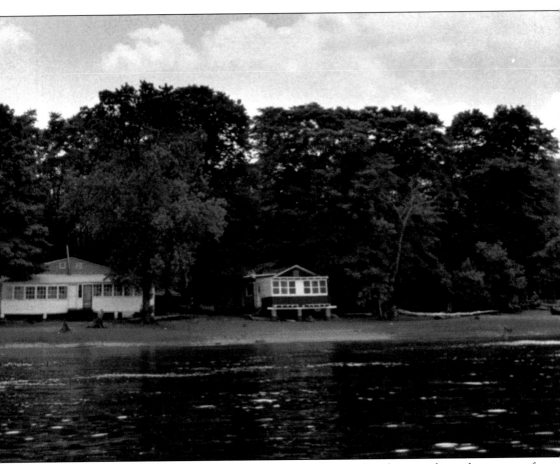

In 1975, Burlington Island was a summer retreat for families from working-class areas of Philadelphia and lower Bucks County, Pennsylvania, who rented land from the Board of Island Managers. The board oversees the educational trust that was established in 1682, when the island was ceded to the city. All revenue from the trust funds provides education for the city's children. The summer cottages were torn down in 1981, three years after the renters left. (Burlington County Times.)

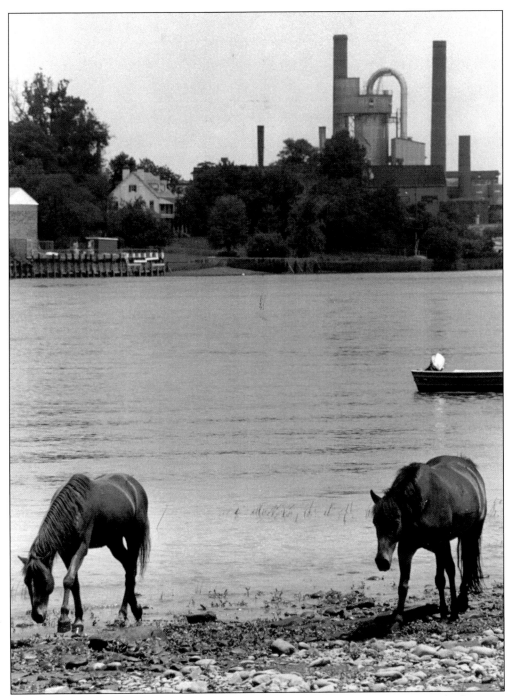

In 1975, some horses made their home on Burlington Island and were photographed grazing along the river with the city in the background across the Delaware River. Today, the island is long vacant, but plans are in the works to develop part of it into an 18-hole golf course. The course, complete with a clubhouse, would be located near a freshwater lake, formed in the island's center when the Warner Company used the land as a source for sand and gravel. (Burlington County Times.)

The Lakanoo Boat Club's scull team regularly competed in the annual river regatta on the Delaware River. Members relaxed on the porch of the club, which was located on East Pearl Street, between St. Mary and Tatham Streets. (Herman Costello.)

The Oneida Boat Club, the oldest continuous boat club on the Delaware River, was founded in 1873. One hundred years after its birth, it escaped the wrecking ball during Burlington's federally funded urban renewal project along the riverfront. Instead, the building was renovated and is now part of the tree-lined promenade. (Herman Costello.)

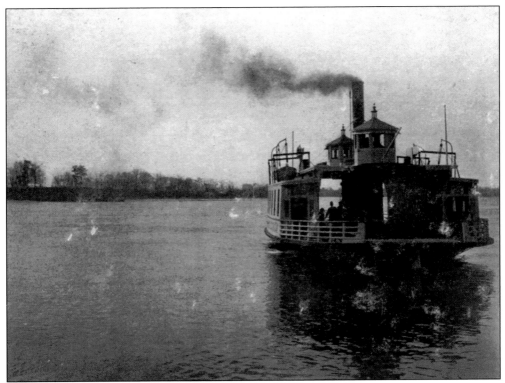

Ferries plied the river between Burlington and Bristol, Pennsylvania, from 1861 until February 25, 1930. The *William E. Doron* was built in 1890 and named for its captain, son of the original ferry operator, Elwood Doron of Bristol. (Herman Costello.)

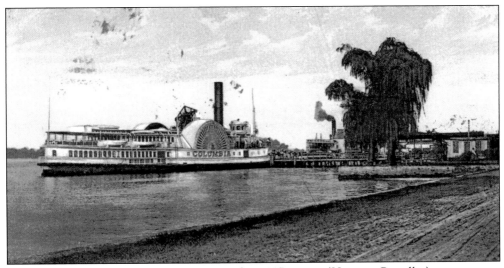

The steamer *Columbia* passes Burlington in this 1907 image. (Herman Costello.)

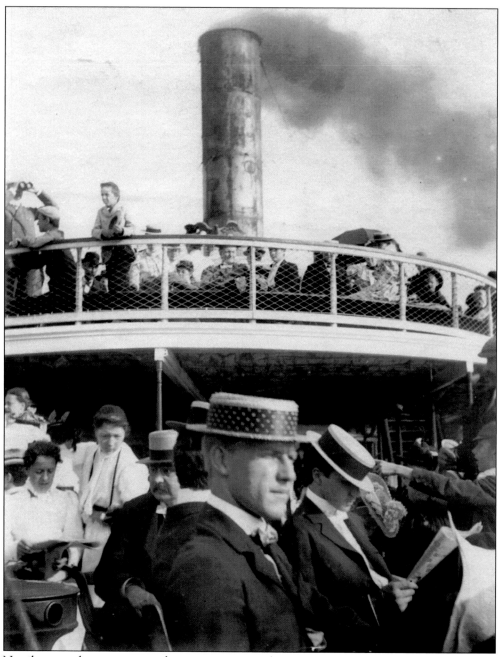

Nattily attired commuters ride a steamer on the Delaware River. (Burlington County Historical Society.)

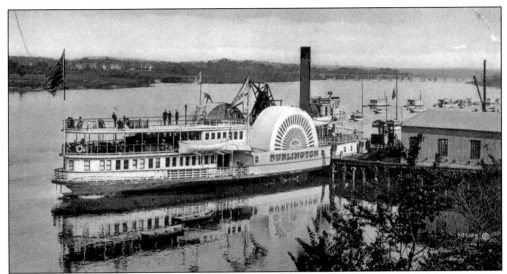

The steamer *Burlington* is seen leaving Trenton in 1909 for a trip to Philadelphia on the Delaware River. There were stops at Burlington and Bristol, Pennsylvania, along the way. (Herman Costello.)

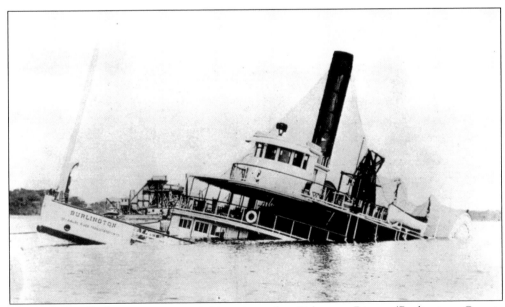

The steamer *Burlington* is seen sinking into the Delaware River. (Burlington County Historical Society.)

Pleasure boats sail along the Delaware River, as seen in this photograph, looking east toward the city. (Burlington County Historical Society.)

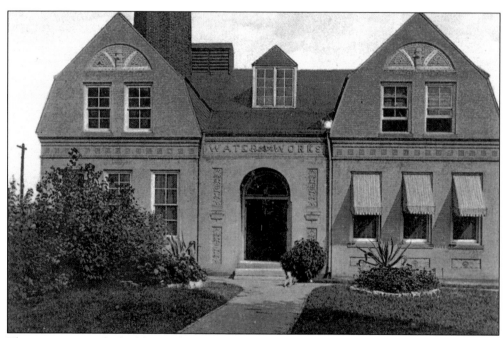

The city waterworks building is located along the Delaware River next to the Oneida Boat Club. Today it is unused. (Herman Costello.)

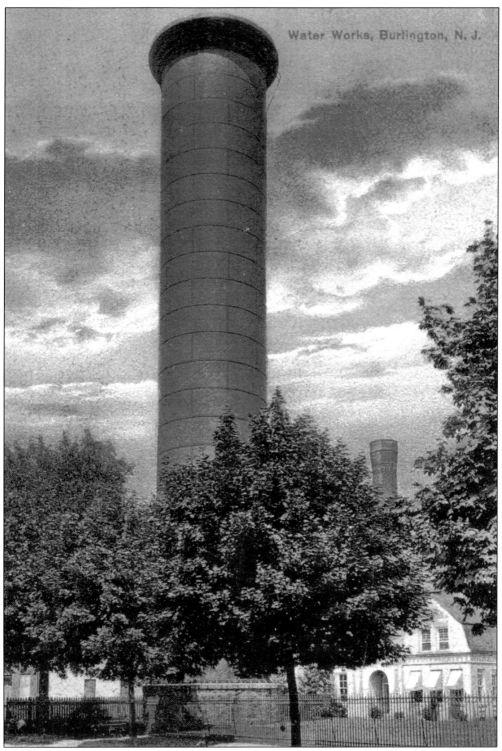

Water Works, Burlington, N. J.

The smokestack at the waterworks served as a guidepost for ships sailing along the Delaware River. (Herman Costello.)

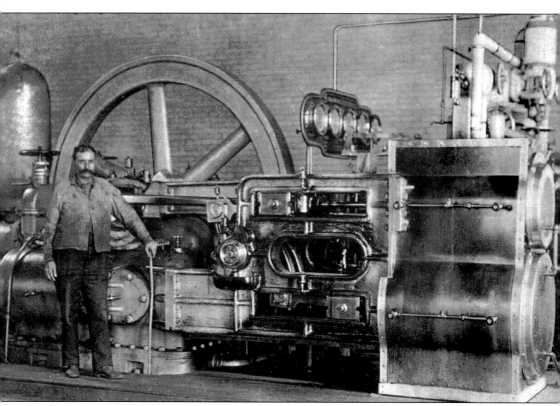

An interior shot shows the pumping engine (and a proud worker) at the city water facility. (Herman Costello.)

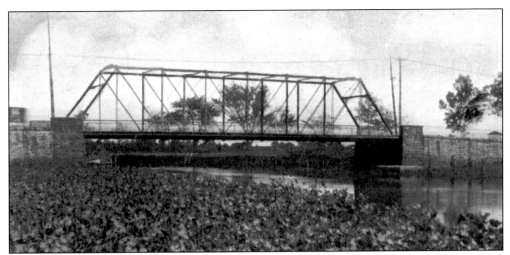

The Pearl Street Bridge, seen in the early part of the 20th century, was reconstructed in 1997 at a cost of $2.5 million. (Herman Costello.)

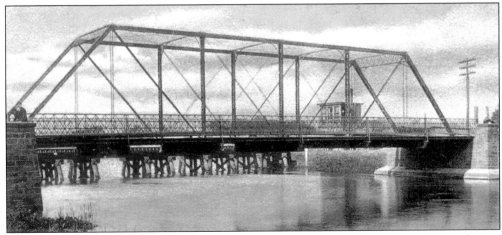

This photograph shows a 1911 sunrise on the Assicunk Creek, a small tributary of the Delaware River, where it is crossed by the East Broad Street Bridge. (Herman Costello.)

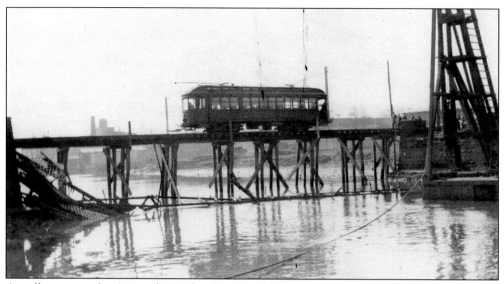

A trolley crosses the Assicunk Creek at East Pearl Street. (Herman Costello.)

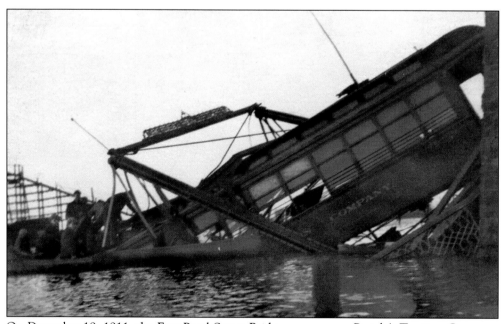

On December 19, 1911, the East Pearl Street Bridge gave way as People's Traction Company trolley car No. 8 was crossing over it. (Herman Costello.)

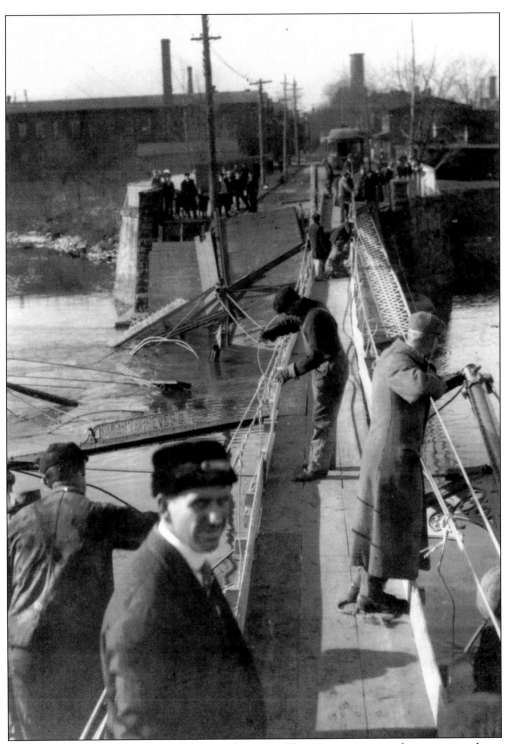

Rescuers work to remove the trolley from the water. The 11 passengers and crew were unhurt. Until a temporary bridge could be erected 10 days later, trolley passengers were taken across the creek in rowboats. (Herman Costello.)

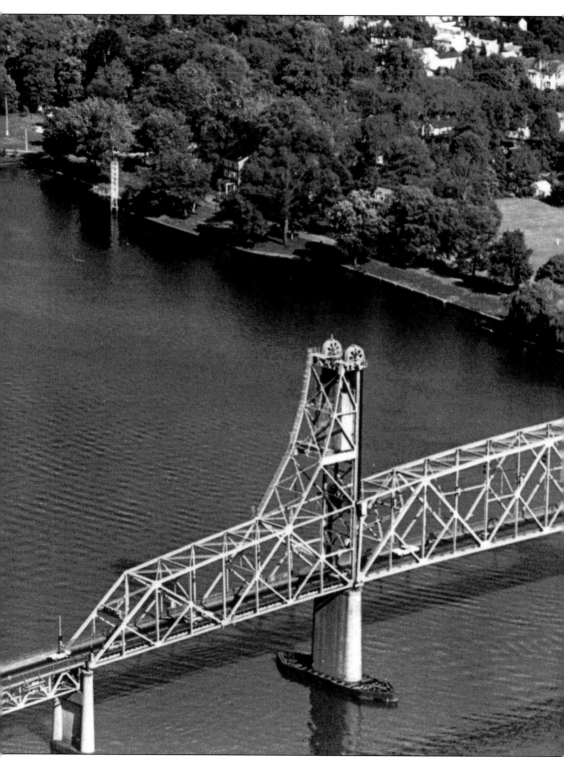

The Burlington-Bristol Bridge, linking Burlington to Bristol, Pennsylvania, opened in 1931, making ferry transportation between the two towns obsolete. The bridge can be opened for

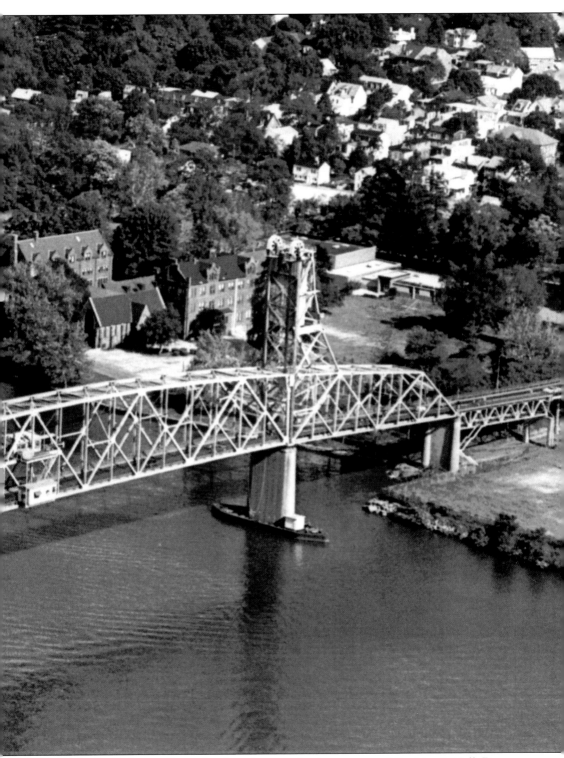

traffic along the Delaware River. In this photograph, the campus of St. Mary's Hall–Doane Academy can be seen to the left of the bridge. (Dennis McDonald.)

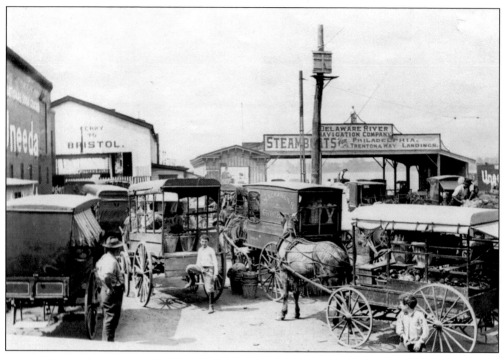

Merchants and their horse-drawn carts line High Street at the dock for the ferry to Bristol, Pennsylvania. (Burlington County Historical Society.)

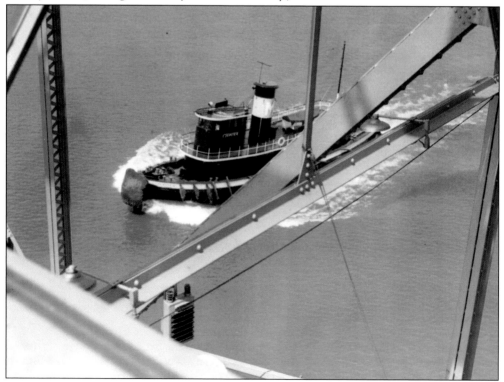

A tugboat passes under the bridge. (Burlington County Historical Society.)

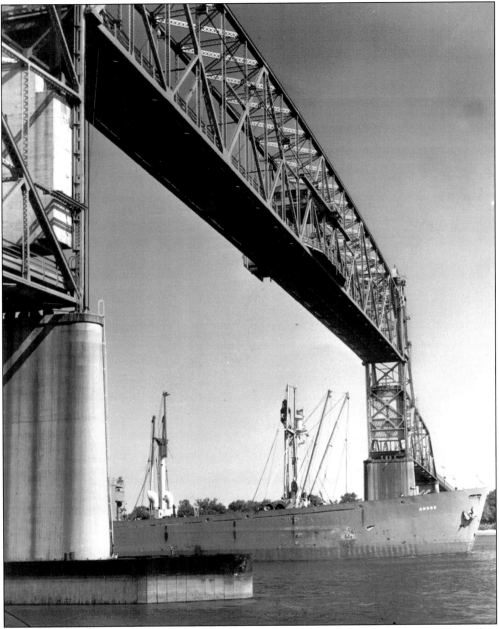

The Burlington-Bristol Bridge, which is operated with concrete counterweights, opens to allow a tanker to pass beneath it. (Burlington County Historical Society.)

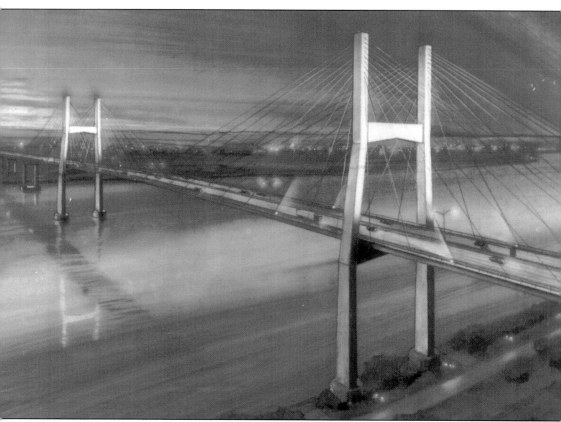

In 1988, a new Burlington-Bristol Bridge was proposed to replace the existing structure, which is heavily traveled and must open to let river traffic through. However, community opposition emerged when it was revealed that many Burlington homes and businesses would be razed for the project, effectively destroying some neighborhoods. To this date, the bridge has not been replaced. (Burlington County Times.)

Five

STREETSCAPES

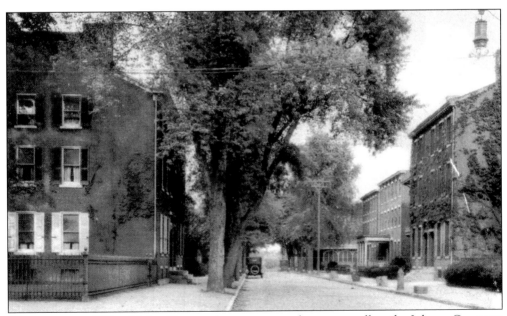

This is a view of West Union Street, where numerous homes as well as the Library Company of Burlington are located. (Herman Costello.)

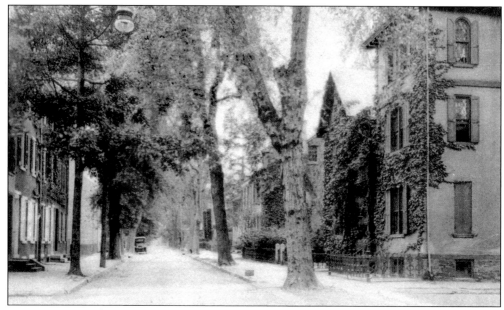

Picturesque Wood Street, with its brick sidewalks, hosts a fair of artisans each September. It used to be known as Professors Row, since several faculty members from St. Mary's Hall resided there. (Herman Costello.)

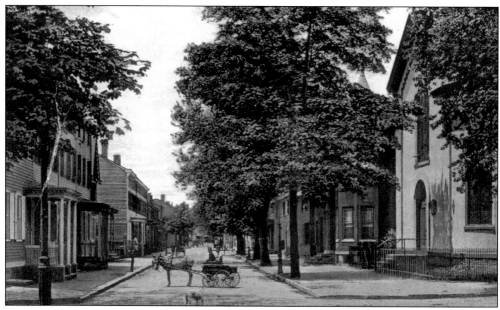

This is a view of East Union Street in 1911. To this day, East Union Street remains one of the city's most historically significant thoroughfares, lined with neatly kept brick row houses, which are more than 100 years old. (Herman Costello.)

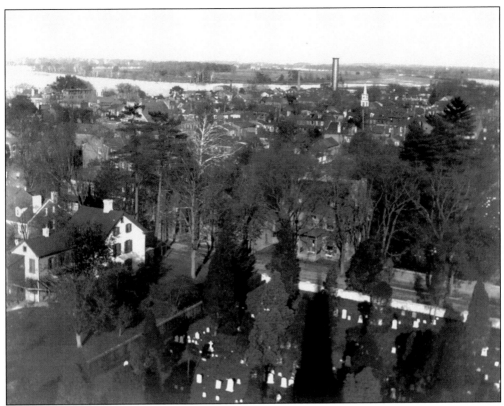

This view was taken from the steeple of St. Mary's in October 1899. (Burlington County Historical Society.)

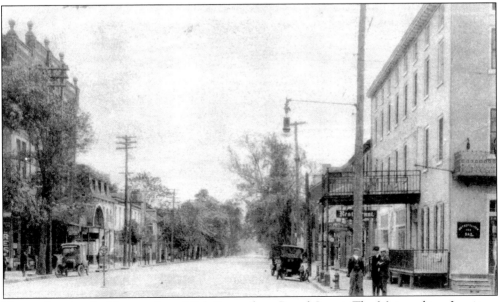

This is the view looking south on High Street from Broad Street. The Metropolitan Inn is on the right. (Herman Costello.)

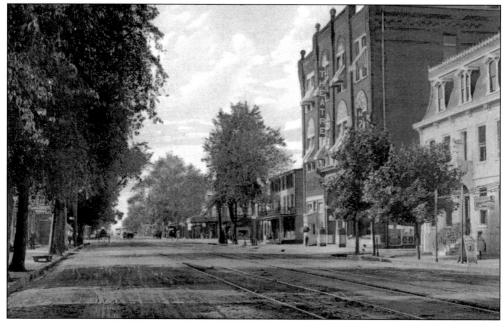

Trolley tracks ran the length of High Street, from the Delaware River all the way to the county seat in Mount Holly. Travelers coming into Burlington could transfer to a ferry that would take them across the river to Pennsylvania. (Herman Costello.)

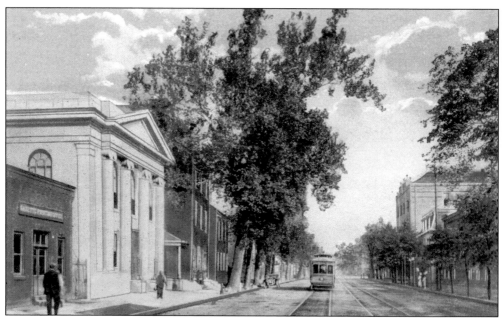

A trolley is about to pass city hall (left) on its way to Mount Holly. (Herman Costello.)

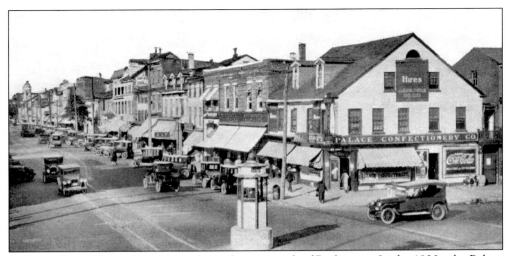

High and Broad Streets have always been the crossroads of Burlington. In the 1920s, the Palace Confectionery Company and the J.G. McCrory five-and-dime store were two of the businesses located at the intersection. (Herman Costello.)

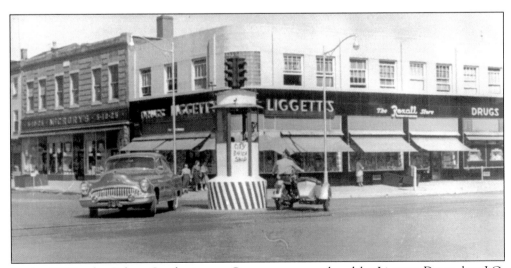

In the 1950s, the Palace Confectionery Company was replaced by Liggetts Drugs, but J.G. McCrory's remained a fixture. (Herman Costello.)

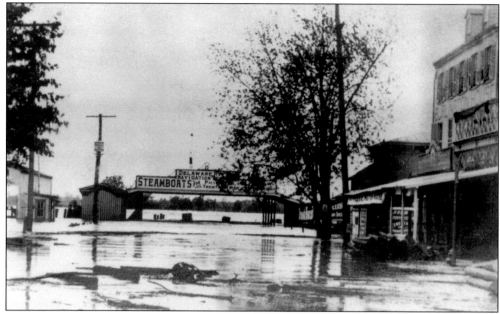

The steamboat landing at the foot of High Street became part of the Delaware River in the 1903 flood. (Herman Costello.)

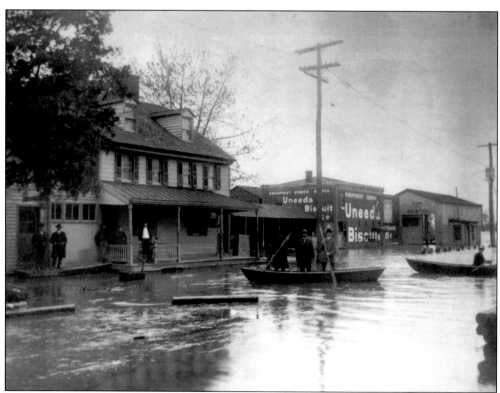

These men are using a rowboat to ford High Street in the flood of 1903. (Herman Costello.)

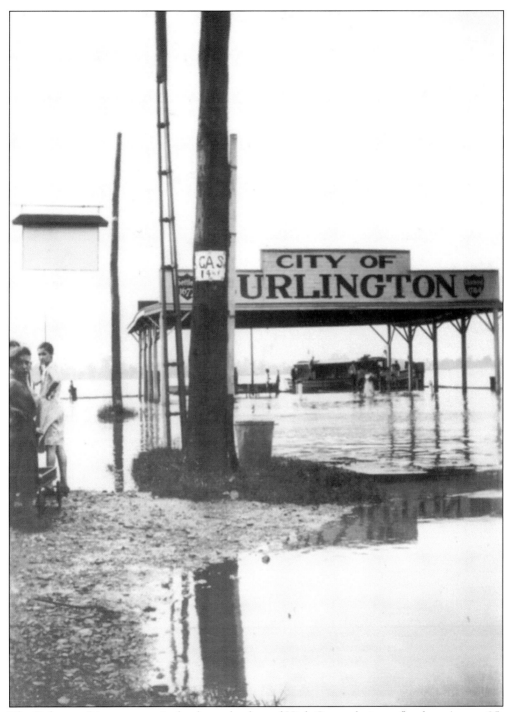

The Delaware River escapes its banks at the foot of High Street during a flood on August 25, 1934. (Burlington County Historical Society.)

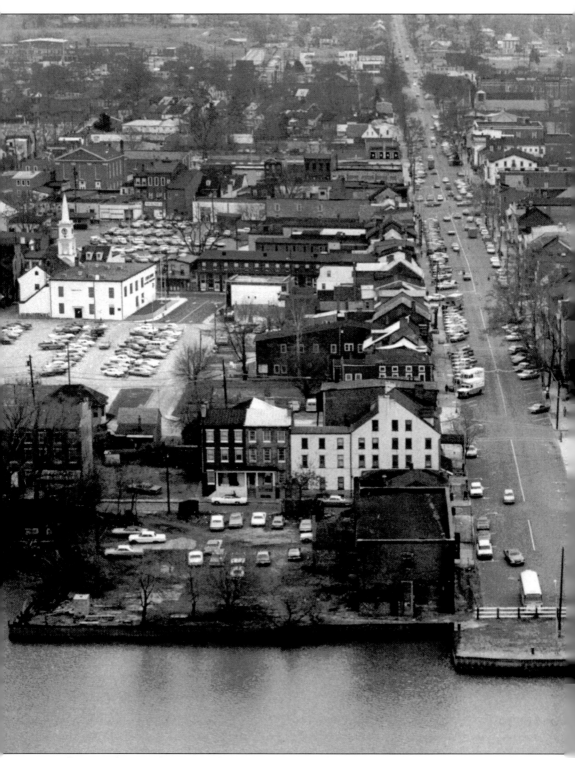

High Street bisects the city in this 1970 view. At the water's edge, the steamboat and ferry landings are still visible. An urban renewal project in the 1970s saw many buildings torn down

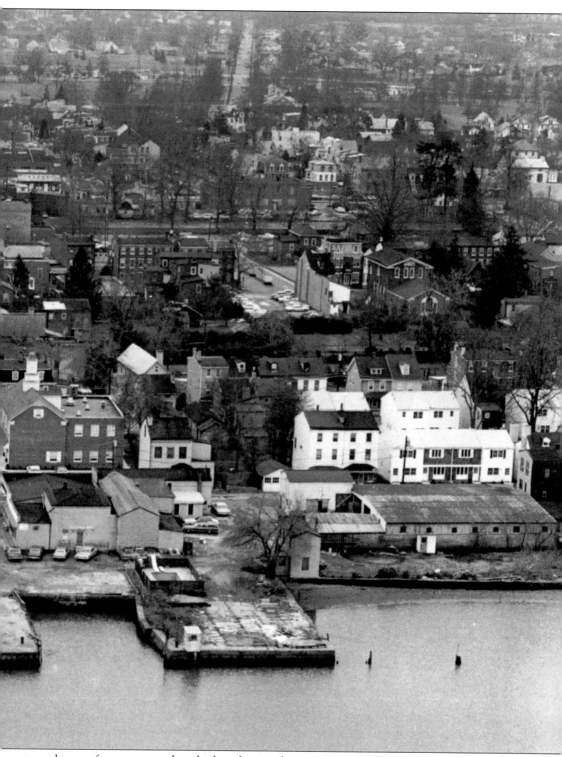

to make way for a promenade, which today is a favorite site for fisherman, tourists, and those who just like to stroll along the water. (Burlington County Times.)

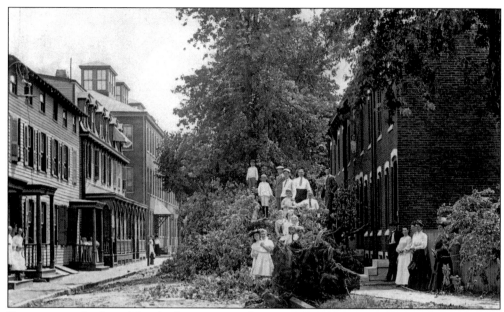

Youngsters and a few adults climb into a tree that was felled when a small tornado hit the 200 block of Penn Street, behind the Quaker School. (Herman Costello.)

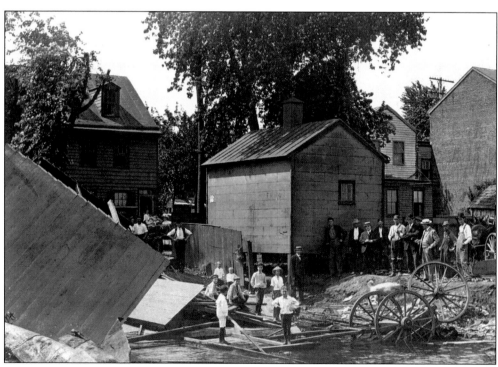

Residents look over the remains of a building destroyed by a tornado that hit East Pearl Street. (Herman Costello.)

Six

COMMERCE

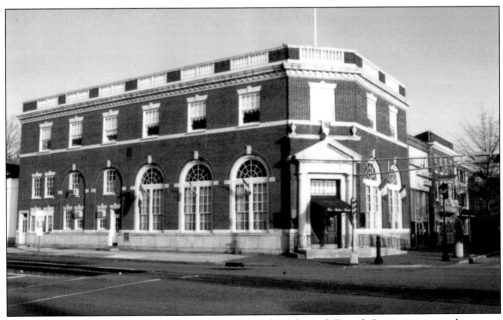

Mechanics Bank, built in 1926 at the corner of High and Broad Streets, is now home to Thommy G's, an upscale Italian restaurant that has retained most of the bank's features. Diners can even be served their meals in an old vault. (Michael F. Shea.)

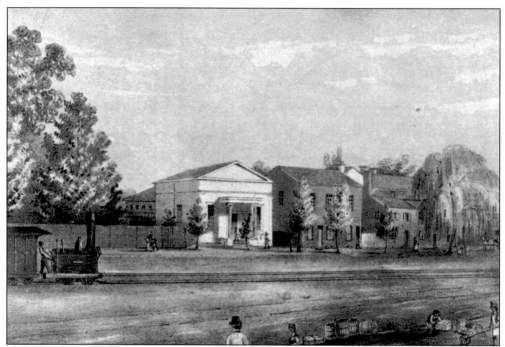

The original Mechanics Bank was located on West Broad Street. It was built in 1842. (Burlington County Historical Society.)

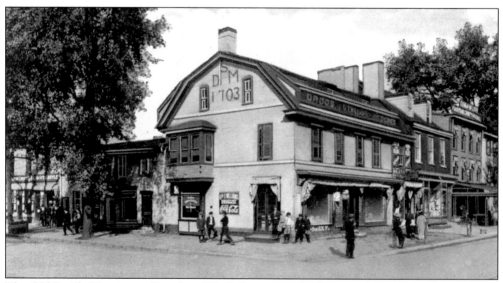

The Old Smith Mansion at Broad and High Streets was built in 1703. First a residence, it was later used as a drugstore. It was torn down in the 1920s so the new Mechanics Bank could be built. (Herman Costello.)

Nathan Haines works at his desk at Mechanics Bank. (Burlington County Historical Society.)

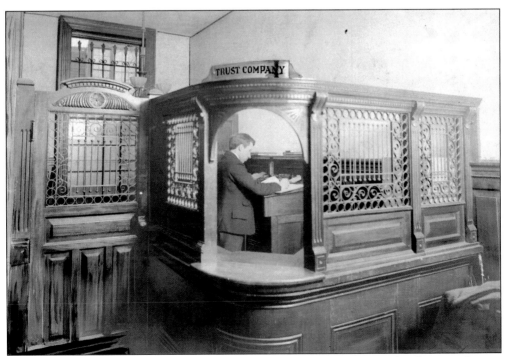

The counting room at Burlington Loan and Trust is shown here. (Burlington County Historical Society.)

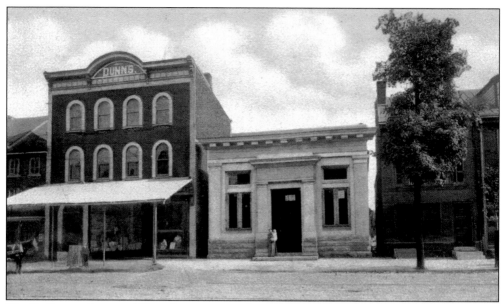

The Burlington Loan and Trust Company was first located in this building on High Street, next to Dunn's Ladies Store, which sold yarn, fabric, and thread to a customer base that fashioned its clothing at home. (Herman Costello.)

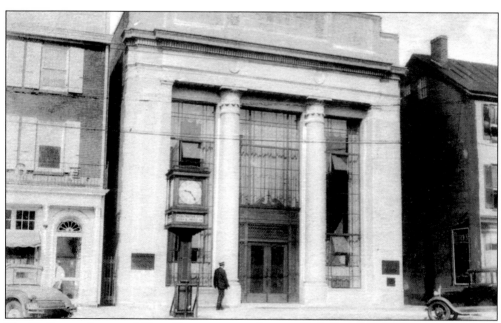

The Burlington Loan and Trust Company moved across High Street from its original location to this formidable building. Today, the building houses a branch of another bank. The landmark clock remains. (Herman Costello.)

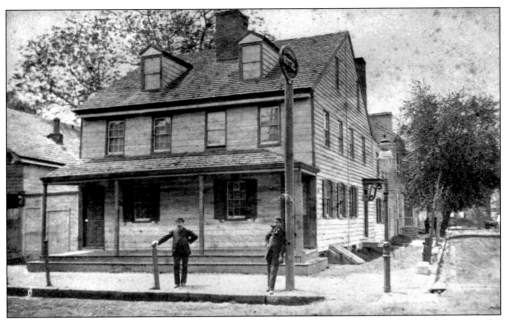

The Steamboat Inn, at High and West Pearl Streets, was a stagecoach and steamboat stop for many years. It later became a social club and today is the site of the Hope Hose Company. (Burlington County Historical Society.)

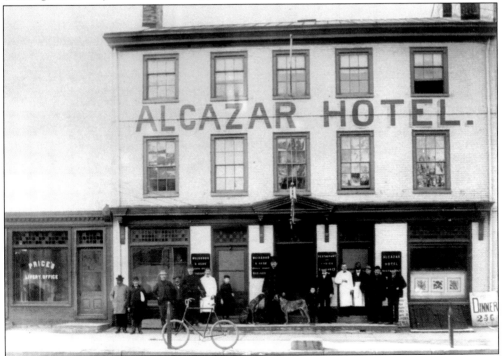

Parts of Alcazar, located at 406 High Street, were built c. 1700. It was first home to Thomas Olive and later trader Richard Smith Jr., who built the Blue Anchor Inn next door. When the Birch Opera House was a popular entertainment venue, Alcazar served as a hotel for performers and fans. (Herman Costello.)

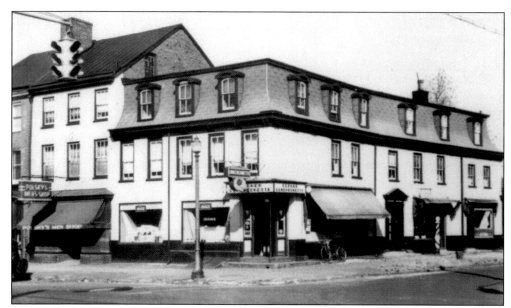

The Exchange Hotel, located at High and Union Streets, was owned by brewer Joseph W. Mailin. (Burlington County Historical Society.)

The Mount and Moody Hotel, seen in 1910, was located on West Broad Street. Today the site is a bank parking lot. (Burlington County Historical Society.)

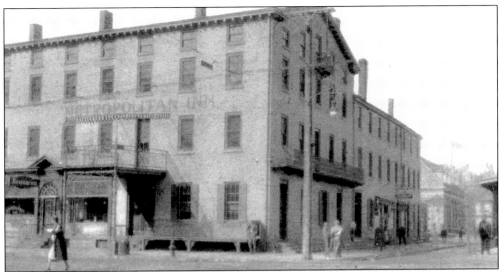

The original Blue Anchor Tavern was built by Richard Smith Jr. at the corner of High and Broad Streets in 1750. The Third Provincial Congress of New Jersey met at the tavern in 1776 and adopted a new state constitution on July 2. During the American Revolution, the tavern lodged George Washington, as well as American generals Knox, Green, Steuben, Cadwalader, Reed, Dickinson, and Maxwell. In 1856, the current Blue Anchor Inn was built on the same site. Known as the Belden House in the 1860s, and later as the Metropolitan Inn and Alexander's Inn, it served such guests as Gen. Ulysses S. Grant, Gen. George B. McClellan, Rep. John McKinley, and Woodrow Wilson. It was used as a Republican headquarters during Abraham Lincoln's presidential campaign and lodged stars of the stage in town for performances at the nearby Birch Opera House. Current plans call for it to be converted into senior citizen housing. (Burlington County Times.)

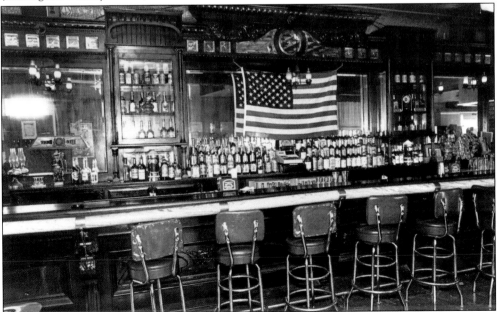

This is how the inside of the Blue Anchor Inn appeared in 1985. Many historical figures, including Ulysses S. Grant, are said to have had a drink at this bar. (Burlington County Times.)

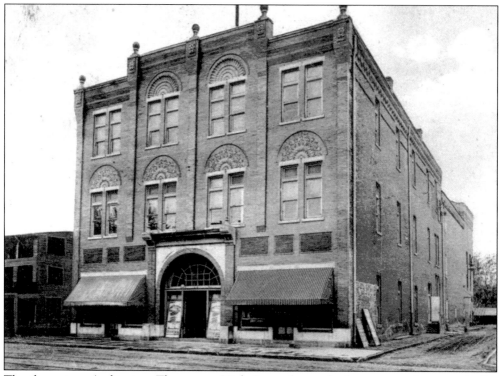

The three-story Auditorium Theatre on High Street featured a large stage where vaudeville performers often put on shows. It was razed in the early 1970s to make way for apartments. (Herman Costello.)

Later, it was known as the Fox Theatre and featured live entertainment and motion pictures. In the 1960s until its close in 1966, it was known as the High Theatre. (Herman Costello.)

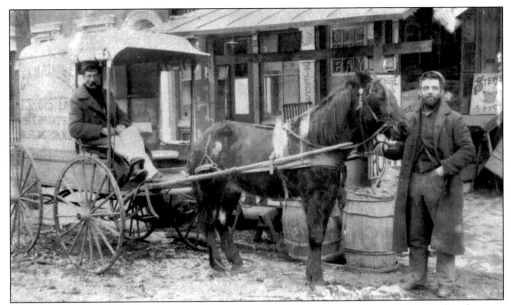

Kenny Mathuse sits in a wagon outside his East Broad Street oyster house in 1904. (Burlington County Historical Society.)

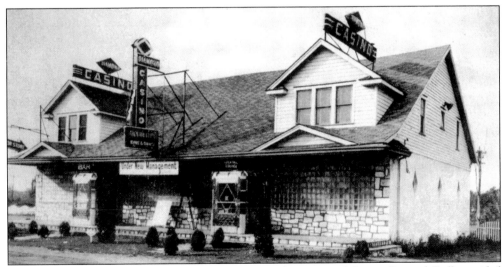

When U.S Highway 130 was still known as Route 25, the Diamond Casino Bar and Grill provided a friendly spot for dinner, as well as a banquet room and liquor store. (Herman Costello.)

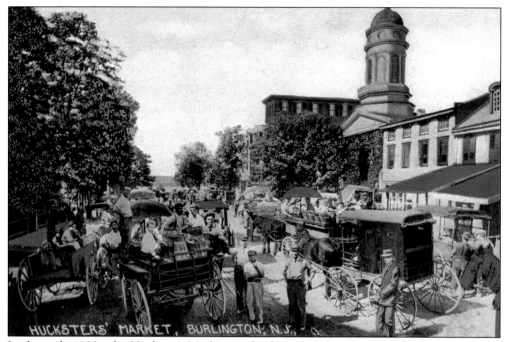

In the early 1920s, the Huckster's Market, at the foot of High Street, saw farmers from across South Jersey gather to sell their produce. (Herman Costello.)

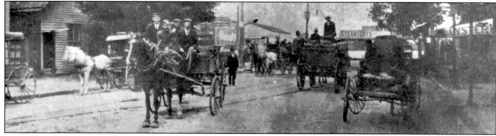

Farmers brought their produce to Burlington to have it shipped across the river to Philadelphia. (Burlington County Historical Society.)

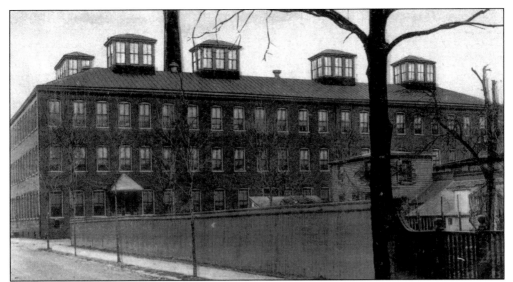

The J.F. Budd Shoe Company was said to be the largest baby shoe factory in the world. Today the building on Penn Street stands boarded up and abandoned. (Herman Costello.)

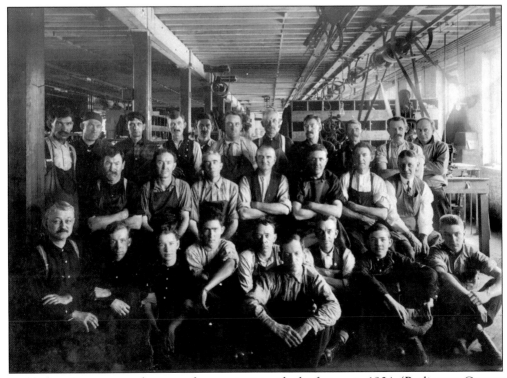

Budd Shoe Company workers pose for a portrait inside the factory in 1904. (Burlington County Historical Society.)

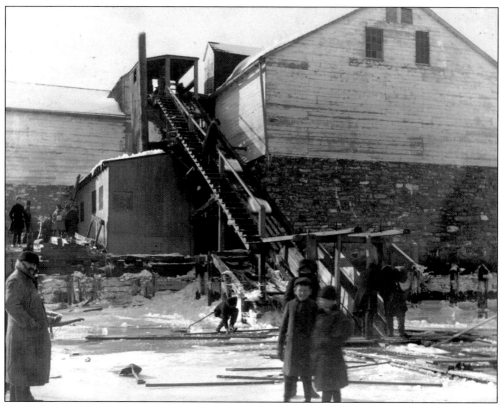

The Peter Vandergrift Ice Factory, seen in 1899, was located on East Pearl Street. (Burlington County Historical Society.)

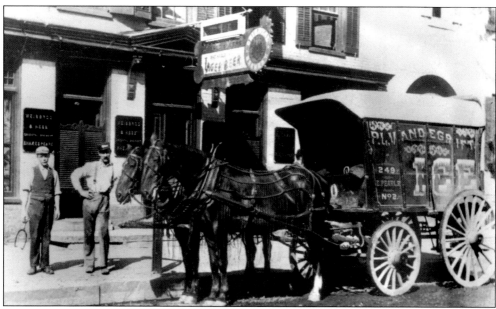

The horses that pulled the Vandergrift ice wagon were also used for fire service. (Burlington County Historical Society.)

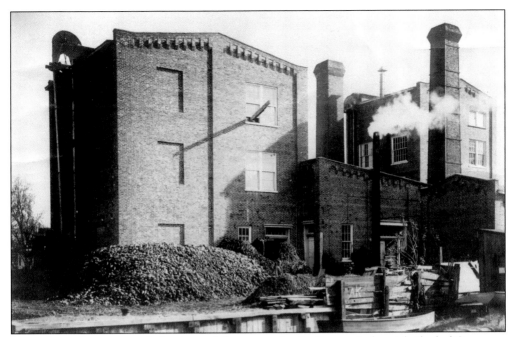

Tons of sugar beets are ready for the mash hopper at the Burlington Industrial Alcohol Company on St. Mary Street at the river. Today, townhouses and condominiums are located on the site. (Burlington County Historical Society.)

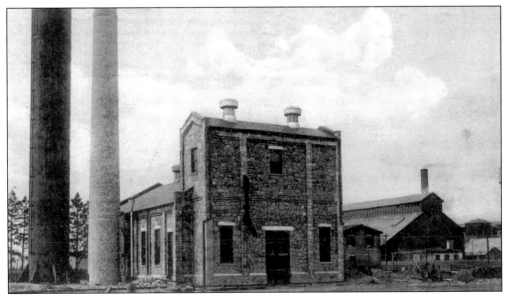

This view shows the powerhouse at U.S. Pipe and Foundry, which has been an active plant on Pearl Street for more than 100 years. (Herman Costello.)

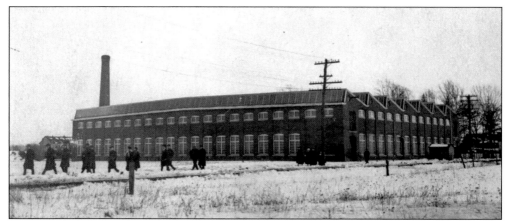

The Burlington Silk Mill, originally located at Pearl and Tatham Streets, moved to this building in the city's Farnersville section in 1910. After its life as a silk mill, it was a shoe factory and later housed an electrical cable company. In 1994, the building, which had been converted into an outlet mall in 1977 that closed in 1989, was destroyed by arson. (Herman Costello.)

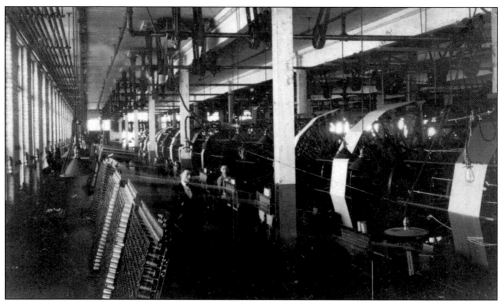

This is an interior view of the silk mill. Burlington residents in the 1830s invested in mulberry seeds in hopes of growing trees whose leaves silkworms would feed on. Two cocooneries were built in the city, but they were soon abandoned when it was found the trees did not grow fast enough to provide food for the worms. The worms—and the so-called silk mania—both died out. (Herman Costello.)

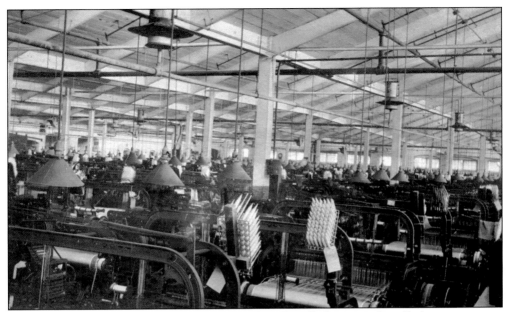
This photograph provides another look inside the silk mill. (Herman Costello.)

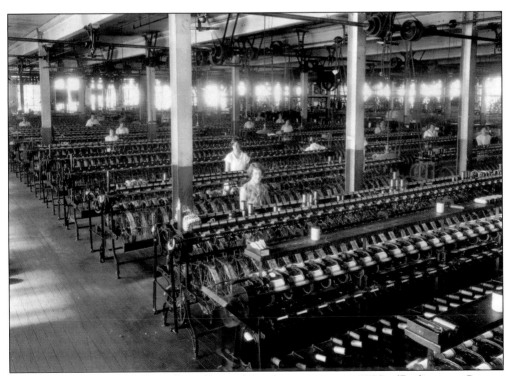
These ladies work in the silk mill winding department in 1928. (Burlington County Historical Society.)

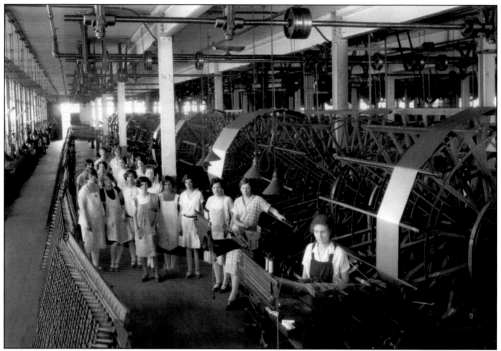

The silk mill warping department and its employees are shown in 1928. (Burlington County Historical Society.)

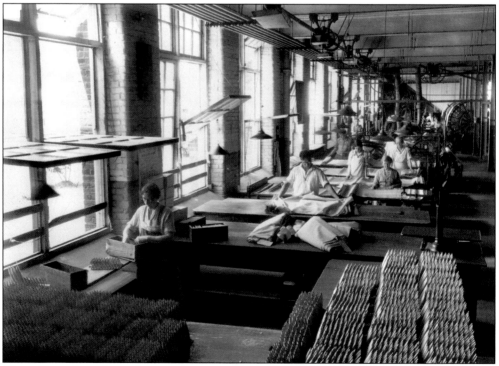

The silk mill picking department was an active place in 1928. (Burlington County Historical Society.)

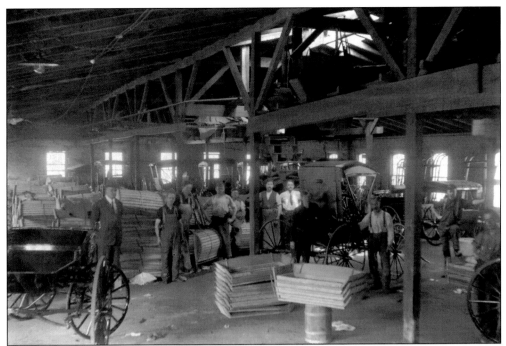

James W. Birch opened a carriage repair shop, the Birch Carriage Works, behind the Birch Mansion at High and Library Streets in 1860. He branched into manufacturing a few years later. He perfected the use of an assembly line to build carriages and rickshaws, which were shipped to Japan, China, and South Africa. The assembly line idea was later employed by automaker Henry Ford. (Burlington County Historical Society.)

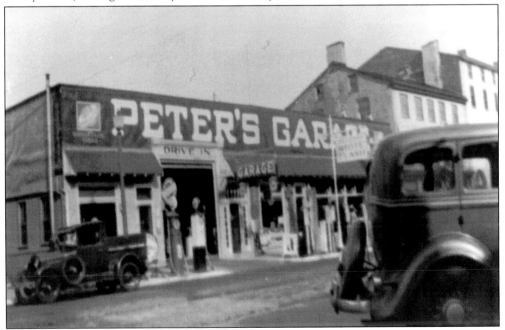

Peter's Garage, once the site of a car dealership, was a popular spot for automobile owners needing gasoline and service. (Herman Costello.)

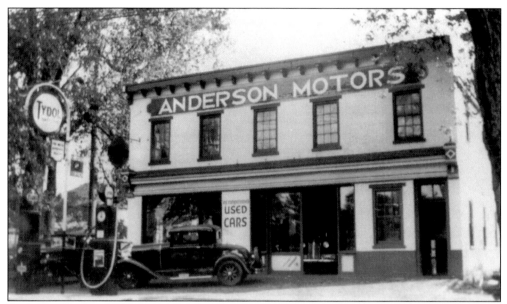

Anderson Motors sold reconditioned used cars and gasoline from this West Broad Street site. It later moved to High Street and eventually became a Chrysler-Plymouth franchise. (Burlington County Historical Society.)

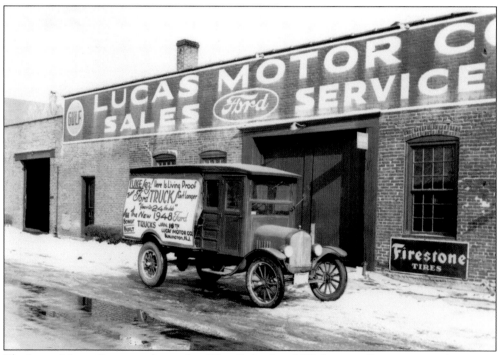

The Lucas Motor Company, located at West Federal and Washington Streets, is now known as Lucas Ford and does business on U.S. Highway 130. (Burlington County Historical Society.)

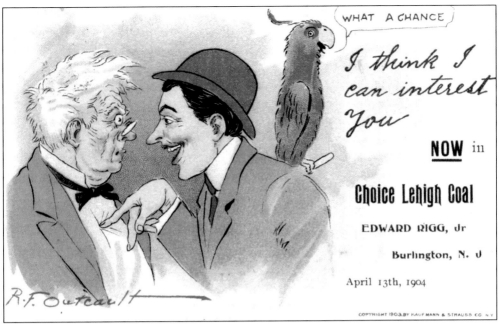

Edward Rigg Jr., proprietor of Choice Lehigh Coal, hoped to entice customers with a cartoon postcard mailed in 1904. (Herman Costello.)

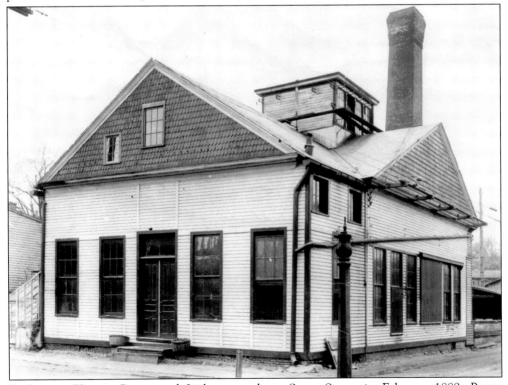

Burlington Electric Power and Light opened on Stacy Street in February 1889. Power generation ended there in 1914, when a new station was opened. (Burlington County Historical Society.)

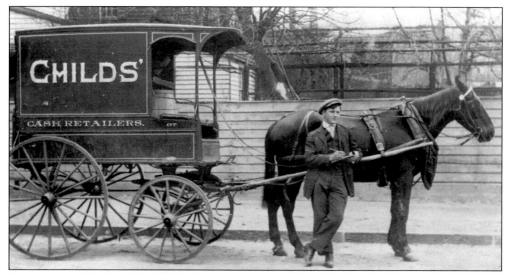

Founded in 1883, the S.C. Childs Grocery Company's Burlington store was located at Broad and Stacy Streets. Orders were taken by drivers, who then returned by horse-drawn cart to deliver the groceries. Childs merged with Robinson-Crawford of Philadelphia in 1930 to become the American Stores, now known as Acme. (Burlington County Times.)

Forrest Curl and the clerks in this photograph worked in Curl's retail grocery business at Union and Stacy Streets. (Burlington County Historical Society.)

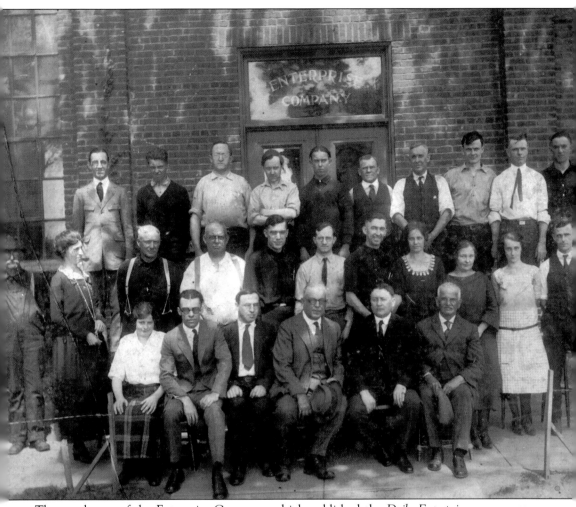

The employees of the Enterprise Company, which published the *Daily Enterprise* newspaper, pose for a group photograph in 1930. (Burlington County Historical Society.)

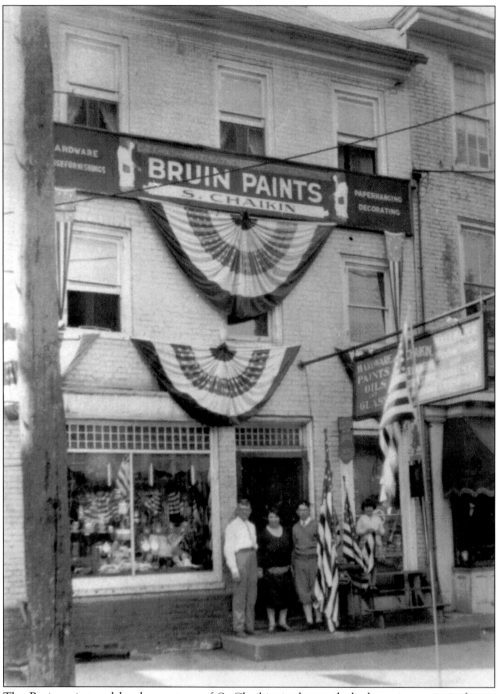

The Bruin paint and hardware store of S. Chaikin is shown decked out in patriotic finery. (Herman Costello.)

Burlington Steam Saw and Planing Mill

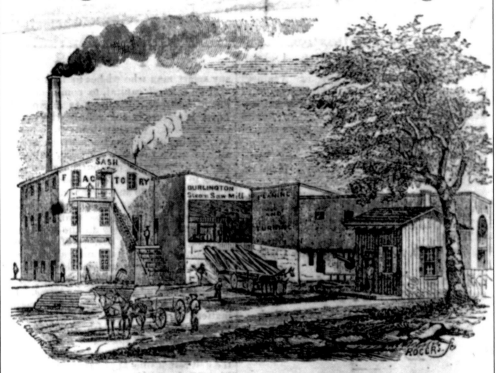

Having put in two new Tubular Steam Boilers of 40-horse power each, built by the Quaker City Boiler Works, of Philadelphia, (John Zeh, Propt.,) with a working pressure up to 114 lbs. of steam per square inch, and being so constructed as to burn our saw-dust and shavings, which will enable us to sell LUMBER at a much lower rate.

COME AND SEE OUR PRICES of the FOLLOWING ARTICLES:

HEMLOCK JOISTS, BOARDS AND PLANK!

WHITE AND YELLOW PINE FLOORING!

WHITE AND YELLOW PINE JOISTS

White & Yellow Pine Boards & Plank, planed or unplaned, well seasoned.

A large lot of HEMLOCK FENCING, at a low figure!

LUMBER OF ALL DESCRIPTION, ALWAYS ON HAND!

50,000 Cedar Shingles 100 000 Heart and Sap Shingles!

UHLER & LATTA,

This 1875 advertisement was for the Burlington Steam Saw and Planing Mill. (Burlington County Historical Society.)

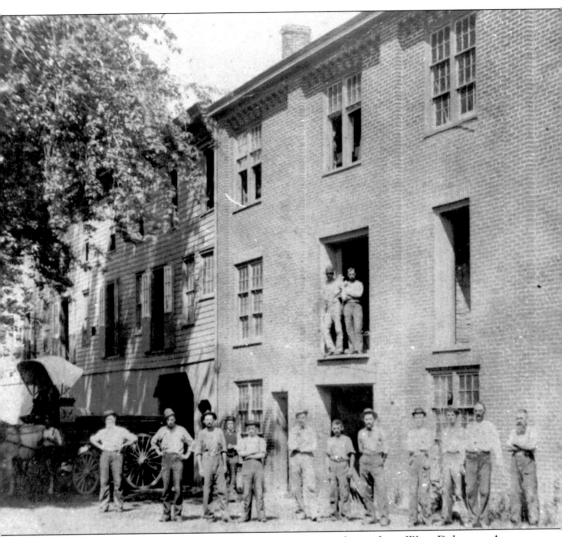

The Severns Lumber and Wood Milling Company was located on West Delaware Avenue.
(Burlington County Historical Society.)

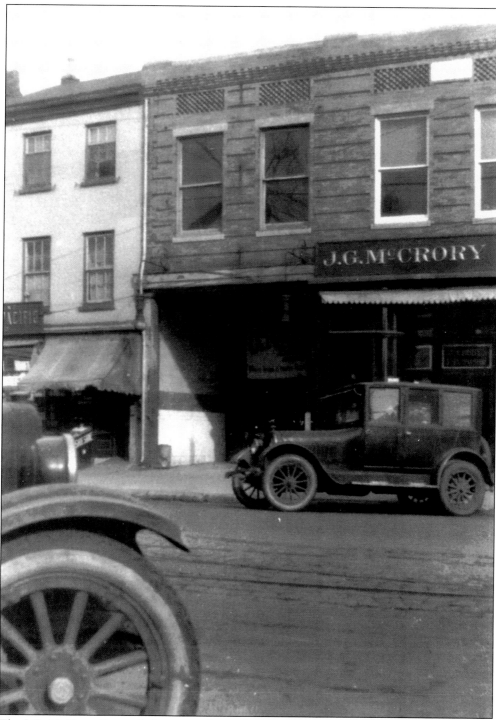

The J.G. McCrory five-and-dime store, located on High Street near the intersection of Broad Street, was in business until the 1990s. (Herman Costello.)

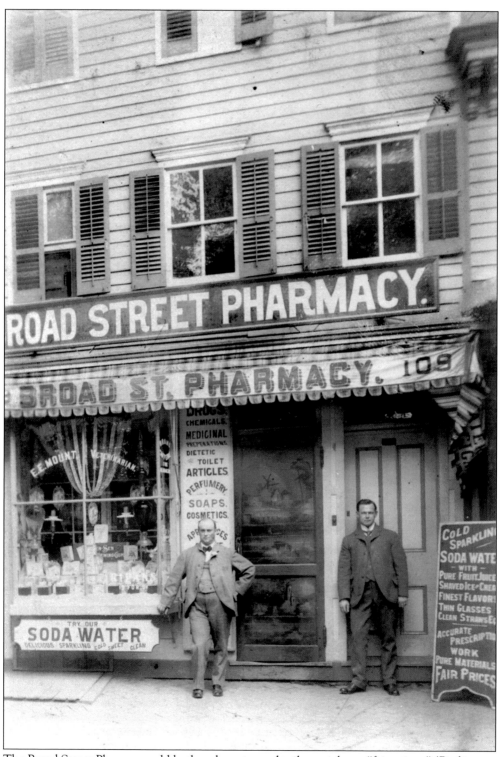

The Broad Street Pharmacy sold both soda water and toilet articles at "fair prices." (Burlington County Historical Society.)

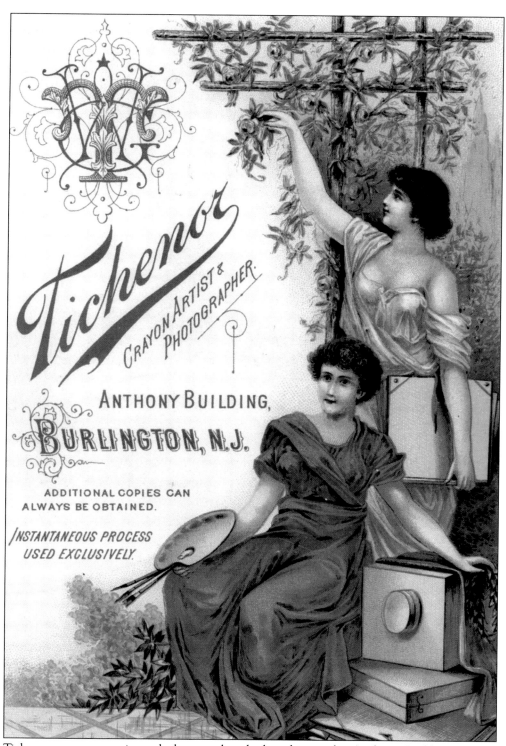

Tichenor, a crayon artist and photographer, had studios in the Anthony Building at High and Union Streets. The building later became a grocery store but has since been demolished. (Burlington County Historical Society.)

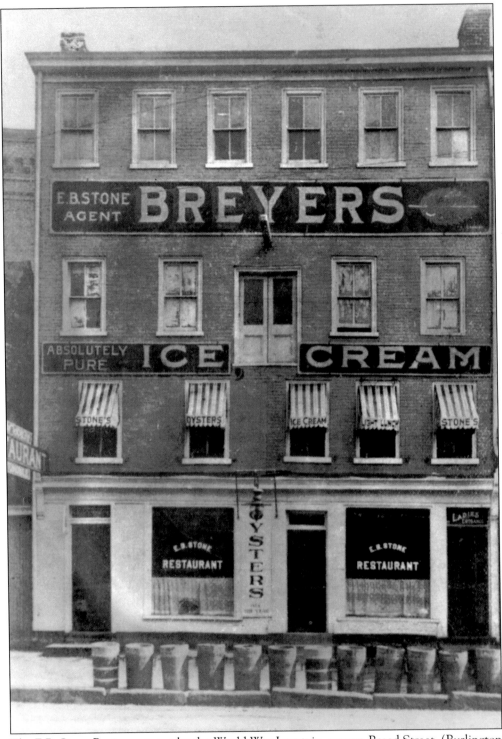

The E.B. Stone Restaurant, run by the World War I captain, was on Broad Street. (Burlington County Historical Society.)

Few communities in the United States can boast of a history as long and as rich as Burlington. Situated on the Delaware River between Camden and Trenton, Burlington was settled in 1677 by English Quakers and named for Burlington, England. The city was incorporated in 1784 and soon became a center for the manufacture of cast-iron products, clothing, and footwear.

Burlington was the capital of the province of West Jersey from 1681 to 1702, and one of the capitals of the United East and West Jersey from 1702 to 1790. In 1726, Benjamin Franklin printed the first Colonial money in Burlington, and the state's first constitution was signed here in July 1776. The city has been home to numerous historical figures, including President Ulysses S. Grant, Captain James Lawrence, and James Fenimore Cooper. *Burlington* traces the city's history from a Quaker community to its prominence as the first Burlington County seat and as a manufacturing center served by railroad and shipping lines. The amusement park on Burlington Island, the construction of the Burlington-Bristol Bridge, the Library Company of Burlington, and the Metropolitan Inn are among the many featured landmarks.

Journalists Martha Esposito Shea and Mike Mathis compiled these photographs with assistance from the Burlington County Historical Society, longtime Burlington mayor Herman Costello, and the *Burlington County Times* making this one of the finest histories of Burlington.

ARCADIA
PUBLISHING

www.arcadiapublishing.com

MADE IN THE USA

Mixed Sources
Product group from well-managed forests and other controlled sources
www.fsc.org Cert no. SW-COC-001530
FSC ©1996 Forest Stewardship Council

ISBN-13 978-0-7385-0916-7 $21.99
ISBN-10 0-7385-0916-7

52199

9 780738 509167

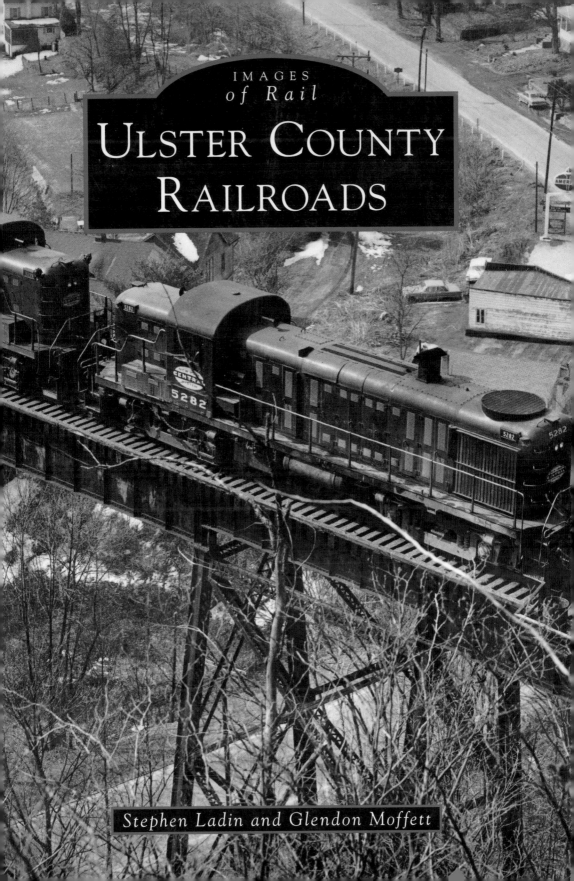

IMAGES
of Rail

ULSTER COUNTY
RAILROADS

Stephen Ladin and Glendon Moffett